PUTMAN STYLE

*"What is style? One point
of view and one only."
Andrée Putman*

Translated from the French by Linda Jarosiewicz and Elena Luoto.

© 2005 Assouline Publishing
601 West 26th Street, 18th floor
New York, NY 10001, USA
Tel.: 212 989-6810 Fax: 212 647-0005
www.assouline.com

ISBN: 2 84323 669 X

Color separation: Gravor (Switzerland)
Printed by Grafiche Milani (Italy).

STÉPHANE GERSCHEL

PUTMAN
STYLE

ASSOULINE

CONTENTS

"To not dare is to have already lost. We should seek out ambitious, even unrealistic projects...because things only happen when we dream."

Andrée Putman

Foreword

I remember walking through the Marais one summer day in 1987.

I still remember the sun, the light wind, a gentle feeling of joy.

I remember the door made of metallic mesh, the large copper aquarium,

the little chair by Mallet-Stevens, the resurrected furniture of Jean-Michel Frank,

the crystal ball at the bottom of the stairs.

I remember the magical, unique light as I crossed the threshold, Jean-Pierre Raynaud's golden pot, the paintings by Bram van Velde and Olivier Thomé.

I remember Andrée's smile, like a sign telling you at each new meeting that anything is possible, that the moment was unique like a window opening onto a new kind of chemistry; a promise of happiness.

Andrée Putman, enchantress of the encounter, makes a success of every new combination. She uncovers your forgotten memories, and makes you see what until that moment had been highly improbable.

Day after day, this magic brings to life the most incredible and least expected combinations—and makes them work.

The art of Andrée Putman, the harmony that comes from her work and gives her staying power lies in this unique and generous gift, this irrepressible instinct that relentlessly persuades people and things that they should not miss the opportunity to say hello, or even, I love you.

François Russo
Co-manager of the Andrée Putman agency

Introduction
to harmony

The contributing elements which eventually founded Andrée Putman's exceptional career originate from her childhood: discipline, harmony, fantasy, and contrasts. The "fifth element" of surprise, would appear later. Discipline was part of Andrée's youth. Early on, her mother decided that Andrée and her sister, Agnès, would pursue the career that she had had to abandon—her girls would become pianists. This was the vicarious dream of a woman who wanted her daughters to experience the career and recognition she had not. From ages 4 to 8, Andrée attended two to three concerts a week, usually early in the morning, and spent hours practicing the piano and learning music theory.

Her mother, Louise Aynard, born Saint-René Taillandier, encouraged her daughters' talent wih unrelenting ambition—they would be the great pianists that she had never become. The only respite the girls had from Schumann were regular trips to the Louvre, her mother saw fit that her daughters were educated in the best classic style. On these daily excursions, Andrée developed her artistic eye. She learned to appreciate obvious aesthetic beauty, acquired the foundations of her style, and formed her own opinions on beauty. This is probably what led Andrée as a teenager to rid her bedroom of all its furniture. In an aesthetic revolt, she decided to oust all the bourgeois embellishments from her room in the sixth arrondissement of Paris. The family apartment had been her protective nest since early

Andrée Putman at 25.

childhood. Gone was the furniture from the age of royalty—Andrée would make do with an iron military bed from the Napoleonic era, and nothing else! Later, in another apartment where the 20 year old Andrée lived with her mother, she convinced her to purchase two armchairs by Ludwig Mies van der Rohe and a ball-shaped chandelier signed by Isamu Noguchi.

Another example of Andrée's strong determination was her rejection of the career her mother had planned, after so many years of studying music. At 19, the famed composer Francis Poulenc presented her with the first prize for harmony from the Paris conservatory. When questioning the master about her future studies, he informed her that she would have to agree to almost total confinement for the next ten years. Upon hearing this, her decision became clear. She would never again touch a piano nor even look at a musical note. Some would see Andrée's legendary use of black and white as the unconscious revenge of the abandoned keyboard.

Soon Andrée turned to Madeleine Saint-René Taillandier, her grandmother and founder of the Prix Femina, for advice. She wanted to end her seclusion and enter the working world right away. Having been deprived until then of the ability to express herself, she could finally be independent. On her grandmother's recommendation, Andrée became a messenger for the fashion magazine *Femina*, the perfect school for a young woman who wanted to discover the world. Among her duties, Andrée transported dresses to photo shoots. There she met designers including Balenciaga, for whom she would design a boutique several years later.

Running all around Paris each day, Andrée spotted bizarre and unique settings that she suggested be used for fashion shoots. Until then these were only done in studios. Soon she was entrusted with scouting

Rice paper lamp, Isamu Noguchi.

On friend Samuel Beckett: "He was almost destitute, but he had twenty dinner jackets.

3

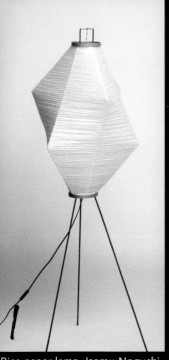

Francis Poulenc.

4

The very well-tempered clavier.

5

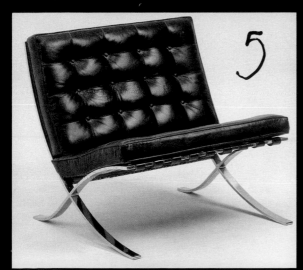

The Barcelona chair by Ludwig Mies van der Rohe.

6

From messenger to stylist, Andrée Putman begins her career at *Femina* and *L'Œil*.

Femina

L'ŒIL

out locations, and eventually styling the sets. Andrée had began her ascent. Next she worked at the magazines *L'Œil* and *Les Cahiers de Elle*. In 1958, she was hired by Denise Fayolle to supervise the home department of the Prisunic stores. In 1968, she followed her when Fayolle joined Maïmé Arnodin to create Mafia styling agency, the first of its kind.

66 When I was little I liked to take risks, and speed fascinated me. I was rather tall and had a big bicycle. I would push it up steep hills, and race down them at full speed. One day, the inevitable happened: I fell and got a terrible cut on my knee. Every morning when I get dressed, I see the little scar. It reminds me of the price paid for my giddiness of speed. 99

Andrée and her sister, Agnès Aynard Brennan.

❝ My mother wanted only one thing out of life, for her daughters to be artists. I found out early that artists help us to understand what surrounds us. We had unbelievable parties at our house, with people from the worlds of fashion and dance, writers, actors, and musicians. I also discovered that creativity is often sparked by nightlife. **❞**

Following page: Andrée Putman and Emmanuel Santarromana.

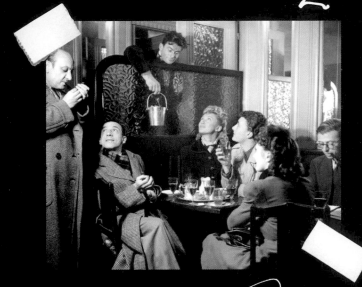

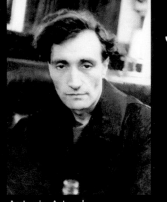

1-2: Café de Flore

Saint Germain des Prés

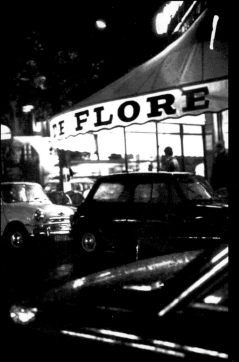

Antonin Artaud.

Alberto Giacometti.

" At 15, I went to the Café de Flore because that was the place to be. To find myself every day between Giacometti and Antonin Artaud, Sartre and Beauvoir, was my addiction. To see them, and perhaps one day speak to them. **"**

TESTIMONY
EMMANUEL SANTARROMANA
The Saint-Germain-des-Prés groove

How did you get the idea of doing a recording with Andrée Putman?

I met her a bit before the opening of Pershing Hall hotel. The construction was coming to an end, and I had been hired to create a musical ambiance around her work. I had never met her before, but I was immediately entranced. I was impressed by the straightforwardness with which she told me that my music was exactly what she had been expecting—"trippy," per her instruction. I was working on an album about Paris, using rhythms from the various neighborhoods. Naturally, one of the songs would be about the ambiance of Saint-Germain-des-Prés, and who better to express it than someone who had spent her life in this neighborhood's clubs?

Her voice seduced you.

It is both classy and hoarse. It tells a story.

How did the project unfold?

At first, I was surprised she accepted. I don't think anyone else had had the idea of making a recording with her and she thought this new area of creativity would be amusing. Then I found myself in the ridiculous position of having to go to her office to audition her. She read this passage by Boris Vian that I had randomly selected, and explained to me what was subversive about it. I was ecstatic.

Tell me about the recording in the studio.

I challenge you to explain to electronic music specialists that you are going to record a jazz piece with the voice of Andrée Putman. At best, I received a few skeptical smirks. But then Andrée appeared, all dressed in black, black sunglasses that she would not remove, even in the dark studio. Everyone was impressed. She embodied the spirit of the Saint-Germain-des-Prés of the 1950s. I noticed she was a bit intimidated, but I the feeling was mutual. Humble as she is, she insisted on twenty takes. Obviously, we only used the first one.

How would you define the "Putman style"?

Ease in subversion.

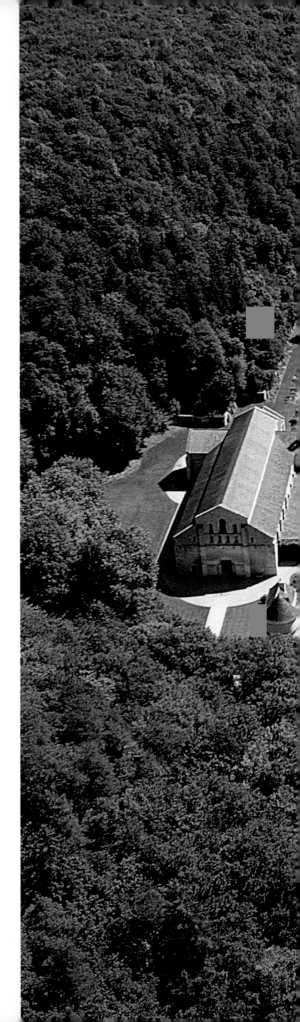

The abbey
at Fontenay

Fontenay Abbey was the setting for Andrée Putman's childhood vacations. One of the first Cistercian abbeys, this religious building came into the Aynard family's possession by inheritance. A famous ancestor, Montgolfier, acquired it to house his paper mill and, incidentally, his aerostatic experiments. The size of the property, which remained in the family, is overwhelming. and it's difficult to take it all in. It is not simply a vast residence or even an immense religious building. Rather, it is the aggregation of one of the largest cloisters in Western Europe, a gloomy chapter house, an even gloomier scriptorium, a mass of pavilions, a refectory, a dormitory, barns, and all sorts of other buildings that once housed the legendary community of monks. Every summer, despite the fifty or more

The Fontenay Abbey, in Burgundy, has been a UNESCO World Heritage Site since 1981.

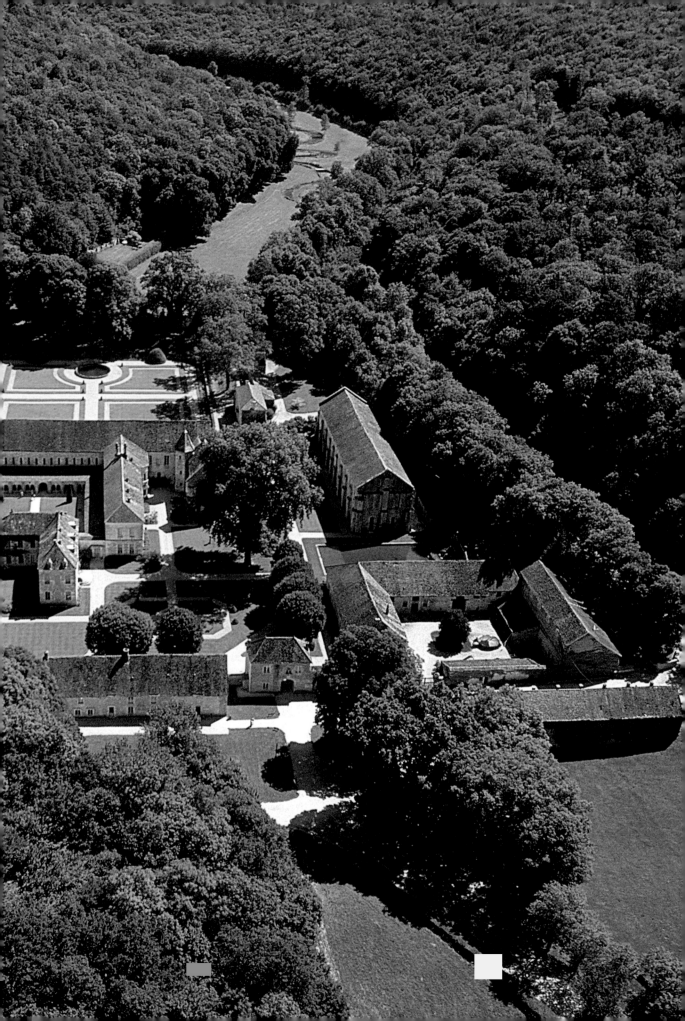

Left: Andrée Putman. Center: Edouard Aynard, Andrée's father, in front of their pavilion at the Fontenay Abbey.

cousins vacationing in the numerous buildings of the abbey, the historical monument was also open to the general public.

The mischievous Andrée wanted to do justice to the monks, whom she felt had been chased away so that the family could settle. Decked out in a chasuble, she amused herself by frightening the tourists walking about. Fontenay also holds the keys to what Andrée Putman values: the vastness and beauty of space, the ascetic severity of the religious buildings, the balance of their arrangement, the focus on the essential and the aversion to the superfluous. In Fontenay, Andrée Putman lived through one of the darkest hours of France's history. In June 1940, while alone with caretakers, the armies of the Third Reich invaded northern France, bit by bit. In Burgundy, the German high command decided to set up

Above: Andrée and her sister.

headquarters at Fontenay. One hundred and fifty SS troops set up camp in the convent. Boots crunching on the gravel, enemy soldiers playing ball on the lawn, tanks parked in the gardens of Fontenay—these are memories impossible for Andrée to erase. The vividness of the images are undoubtedly part of the uneasy feeling that Andrée has on each visit to Fontenay. To this day, the sentiment persists, despite the intensity of the calm, serene summers that followed, despite the loving care of her cousin Hubert Aynard, whose untiring work to preserve and restore the place allowed it to be listed as a UNESCO World Heritage Site in 1981.

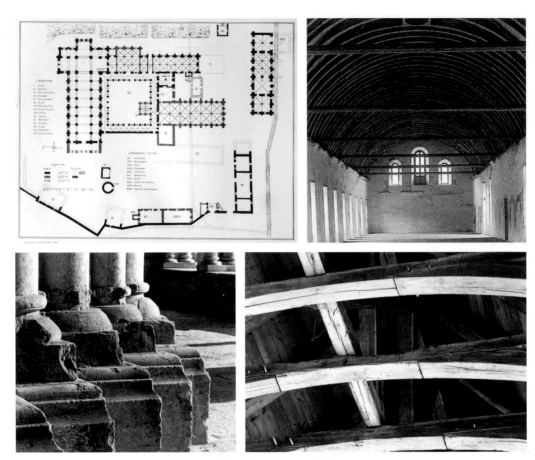

Details of the Fontenay Abbey.

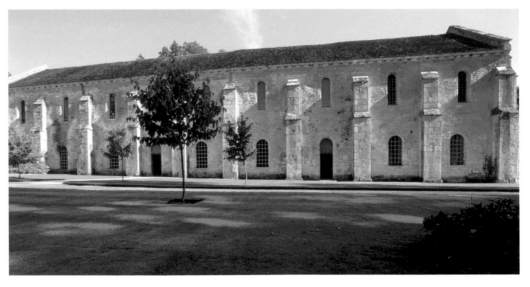

Above and opposite: Today the nave is used for exhibitions.
Following pages: At Fontenay, a pillar of the chapter house, and the cloister's walkway.

x

24

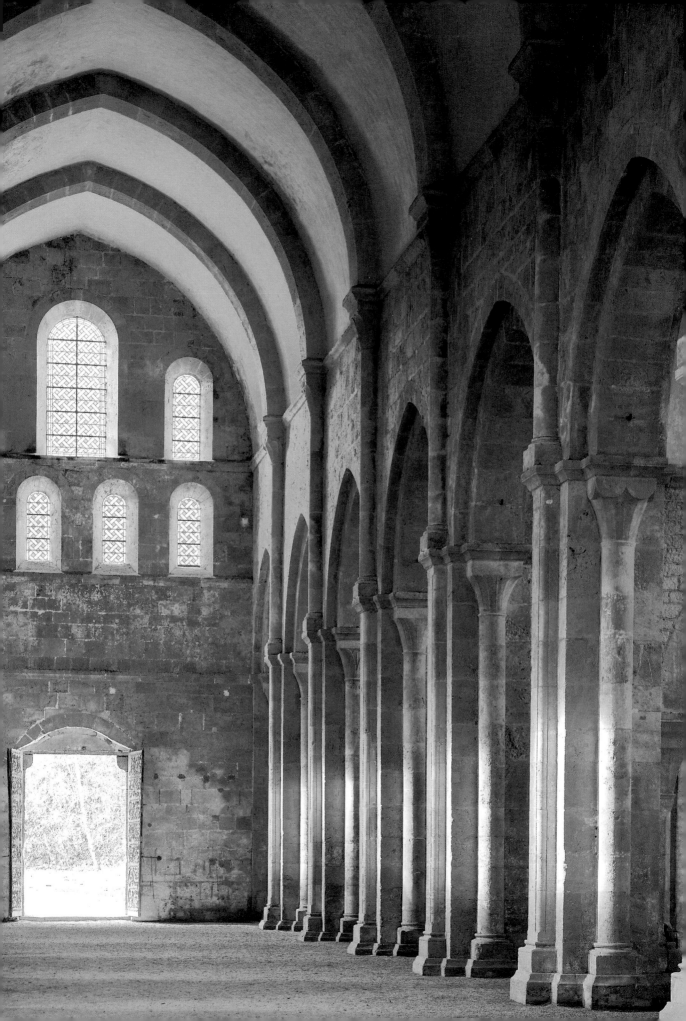

Early *successes,*
and *hardships*

In 1958, Andrée Putman joined the French department store Prisunic to manage the style of the household division. One of her obsessions was to bring contemporary art to the masses. She implemented a new idea. For 100 francs at the time, one could buy a limited edition lithograph signed by one of the avant-garde artists who were part of Andrée's circle—Pierre Alechinsky, Bram van Velde, Niki de Saint-Phalle, among others. Contemporary art had suddenly become part of daily life. The outcome was mixed—friends of the Putman's, sensing a good thing, snatched up the collector prints depriving the general public of the opportunity. However, the objective had been acheived, art had entered the mainstream. The movement had begun; there would be no turning back.

In 1968, Andrée's next step was to join the Mafia agency. She became known for her independent spirit, her radically innovative choices, but also for her meticulous attention to detail. Her work ethic and the fact that she would never give up, displayed her inexhaustible energy. Combined with her social inclinations, Andrée became a demanding artistic director by day, and a relentless party goer by night.

The year 1971 was the start of an adventure so far ahead of its time that it can still be considered avant-garde today. Didier Grumbach hired Andrée Putman to launch Créateurs et Industriels. Set up a few steps from place Saint-Germain-dea Prés, in the lower rue de Rennes, the

Andrée Putman at home in the 1960s.

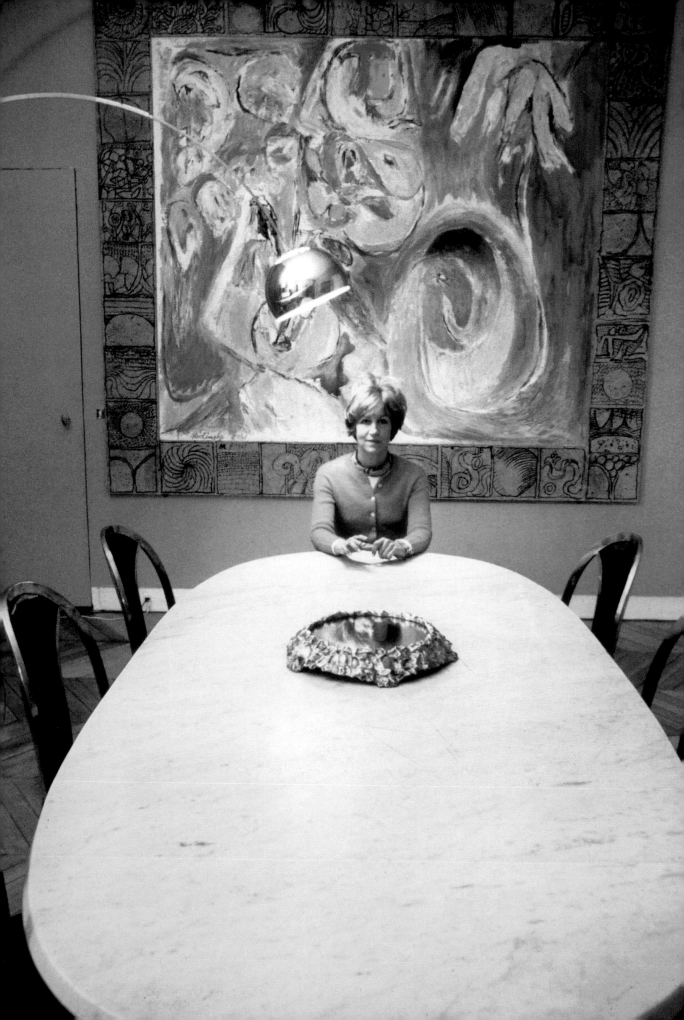

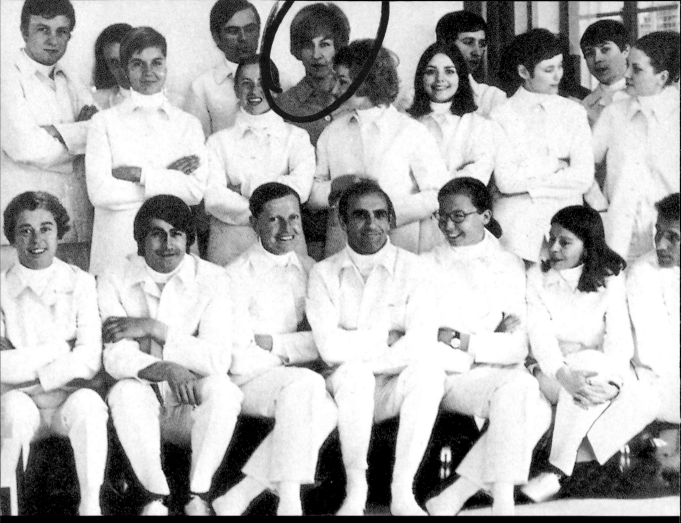

Above: Group photo at Mafia. Already rebellious, Andrée Putman refuses to wear the compulsory white uniform.
Opposite: Private correspondence from Niki de Saint-Phalle and Jean Tinguely to Andrée Putman.

66 I have a very moral soul; I was taken by French artisans and the price of things. 99

company, as its name implies would be the first encounter between fashion designers and the mass production of their creations.

Didier Grumbach, heir to the clothing factory Mendès, founded the fashion industry as we know it and invented prêt-à-porter. A visionary, Grumbach imagined that designers would have an audience, and would have to respond with larger scale production.

Artistic director of the enterprise, Andrée Putman met the young Jean-Paul Gaultier who had come to show his first pieces of jewelry. Jean-Charles de Castelbajac, a then 18 year old, was promising talent making himself known. Soon came Emmanuelle Khanh, Issey Miyake, Claude Montana, and Thierry Mugler, all of them were introduced by Créateurs et Industriels. The company needed a home in keeping with its style. Andrée Putman gave the headquarters, settled in an old railway warehouse, the nobility of an industrial loft. She organized the new designers' first fashion show in the rotunda of the Paris trade exchange building. International buyers and press were already fighting over the first rows.

Unfortunately, the poorly financed, pioneer enterprise quickly ended, leaving behind the melancholy of projects too soon abandoned. But it had started the ready-to-wear revolution. Andrée weathered an unpleasant divorce and took refuge with her supportive friend, Michel Guy. To help her get through this difficult time, she decided to create Ecart.

Following page: Andrée Putman and Didier Grumbach.

1

Portrait of Andrée, by Bram van Velde.

Andrée Putman and Prisunic,
beauty designed for everyone.

2

prisunic

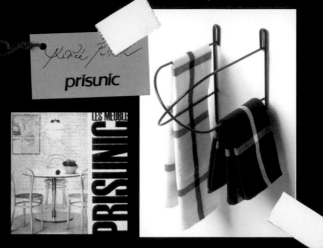

3

The "Prisunic years"

4

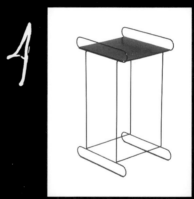

3-4. Small metal furniture
set for Prisunic.

5

Bram van Velde.

"My career during the Prisunic period: popular style."

TESTIMONY
DIDIER GRUMBACH

The first show by Jean Charles
de Castelbajac organized
by Créateurs et Industriels, 1972.

How did you meet Andrée Putman?
It was Christmas 1970, in Quiberon. Louison Bobet, one of the first spas in France, had just opened. A few celebrities were staying there. A mutual friend introduced us. I was looking for an artistic director, and she joined me a few months later.

What was Créateurs et Industriels?
It was a project I had for some time. The idea was to bring together manufacturers, mainly of textiles, and innovative designers of the time. I thought that couture was dead, and I wanted to promote new talent: Issey Miyake, Jean Muir, and Emmanuelle Khanh were the first to take part in the adventure. We started out on the Mendès premises, and later found an extraordinary warehouse where we decided to create the event.

What role did Andrée Putman play?
To begin with, her architectural work was striking. The old railway warehouse was cleaned, simplified, and stripped. We kept the Paris cobblestones that came right inside the building. We uncovered a glass roof, and there was a staircase lacquered Chinese red that led to the gallery. We designed it that way so that each object would be its own showcase. And then her choices were extraordinary. You could find the perfect cloth; stationery in fourteen colors; exotic plants; jewelry by Elsa Peretti; lingerie by Fernando Sanchez; an impeccable, black English bicycle; a single set of china—but the very best—from Coquet. One day we would organize a pony sale,

and the next week sell tulip bulbs, garden dresses, benches, and lithograph prints by Jean Messagier.

How did the Créateurs et Industriels adventure end?
The end of Créateurs et Industriels was a sad time in our lives. We were financially dependent on Japanese investors who did not appreciate the avantgardism of all these choices. We ended it on friendly terms, though. The project could have survived, it's just that some people were lacking the drive.

You entrusted her with several projects, including your New York apartment.
My apartment in New York was a veritable showroom for Ecart International. It was photographed several times.

Constructible Cloth, Issey Miyake, 1969.

The Yves Saint Laurent boutiques in the United States, and the Thierry Mugler boutiques in Paris, were they also your doing?
The Yves Saint Laurent Rive Gauche label was a subsidiary of my family business, Mendès, and came to be because of an agreement I made with Pierre Bergé. It included boutiques in the United States. The one in Bal Harbour, Florida, especially attracted a lot of attention.
After having sold Mendès—the best day of my life—I decided to finance Thierry Mugler, who we had discovered at Créateurs et Industriels. Of course, we asked Andrée to design his first Parisian boutique.

What are the specific qualities and attractions of your current offices, at the Fédération de la haute couture?
The place was neither amusing nor outstanding; the only remarkable thing about it was the view overlooking the presidential palace. The layout of the office space was so unattractive that Andrée Putman was reluctant to accept the job. But she cleared it out and created a large, serene, comfortable, and completely timeless space.

How would you define the "Putman style"?
Andrée Putman is the federator of French style in the twentieth century—and that is unique. While others may have their own style, she is obsessed with timeless interiors. From the start, Andrée Putman has mixed everything together. She rejects any segmented view on fashion, design, or contemporary art. It is this side of her—the eternal seeker—that is totally unique and that I find absolutely extraordinary. She has the ability to collect complementary works from different eras, and to involve designers from all walks of life in her vision.
Andrée Putman has decompartmentalized design. Her vision was new and different, a veritable forerunner, but unconsciously we were waiting for this vision, so it was right on.
She is the very image of all this. She has an impressive sense of detail, strict ideas about the rendering, the finishing, the accuracy of proportions, the exactitude—from all points of view.

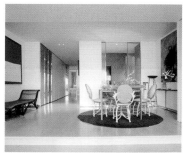

The Parisian apartment
of Didier Grumbach.

Michel Guy & Andrée Putman
The accomplices

It was Igor Eisner, a journalist and friend of Andrée's, who introduced Michel Guy to the Putmans. Jacques Putman, an art dealer, and Guy, a dilettante heir, became friendly acquaintances based on the work of Bram van Velde, one sold while the other collected. And with Andrée, Guy quickly formed a steadfast friendship. Andrée's social disposition was difficult to reconcile with her husband, a solitary man known to be somewhat of a misanthrope. He rarely left their Grands-Augustins apartment, where he would receive suppliers, artists, and clients with similar nonchalance. His long meditative days left Andrée craving company; her closeness with Michel Guy filled this void.

Not even 30, Andrée Putman and Michel Guy were living the upper-class Parisian life, though they managed to avoid most of its obligations. Driven by the same passions and curiosity, they navigated the Paris streets day and night in Andrée's beige Austin Mini with tinted windows. Befriending Beckett and Ionesco, they discovered the illicit seductions of the night-owl crowd.

Uncle Michel, as Andrée's children called him, soon discovered his young friend's qualities, such as her remarkable ability to unearth rare, precious, and incongruous objects among the most unlikely bric-a-brac. He decided to ask her for help in furnishing his pied-à-terre. Andrée adeptly chose things perfectly suited to his single lifestyle. Her recommendations were so accurate that he ended up seeking her expertise with all his other apartments.

Michel Guy, French minister of culture, in 1974.

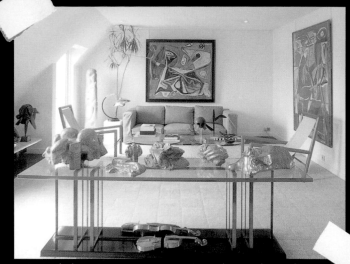

2

At Grimaud, Andrée Putman and Michel Guy.

2–3. Michel Guy's current apartment, on the rue de Rivoli in Paris.

3

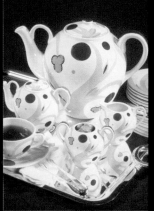

My first client

At Saint-Tropez, the first apartment designed by Andrée Putman.

4

Polka tea set, designed
by Andrée Putman,
Gien pottery, 2003.

5

Of course, adhering to the conventional layout of an upper-middle-class home seemed absurd to Andrée. Thoroughly familiar with her friend's habits and quirks, she was able to invent the perfect place to fit his style. First she systematically rearranged the rooms. Aware that her friend had a tendency to live in his bedroom, she knocked down the partitions and installed a reading sofa that doubled for receiving guests, and a work table. Since he never dined at home and hated cooking odors, she decided the kitchen would be hidden like a cupboard, isolated, and restricted to a most simple form. For the first time, Andrée Putman was practicing the art of which today she is the uncontested master: creating a space that is a portrait of its occupant by taking into account their individual lifestyle and idiosyncrasies.

In return, Michel Guy vowed an ardent loyalty to Andrée Putman and her talents. No object could enter any of his residences without his accomplice's stamp of approval. Once, during the renovation of his latest apartment on rue de Rivoli, he dared to unpack a few pieces of Empire furniture he had inherited. Andrée's terse judgment fell like the guillotine's blade: "Where would we put them?" That was the last that was seen of his stuffy antiques.

Appeciative of Andrée's avant-gardism, Michel Guy never hesitated to promote her. When he was named minister of culture in 1974, he often invited her to accompany him on his official trips. She particularly enjoyed travel to Soviet Russia, from where she recalled the memory of a samovar that served as the inspiration for a teapot she would design some thirty years later.

When Jacques and Andrée Putman divorced, a dark period that coincided with the collapse of Créateurs et Industriels, naturally Michel Guy took in his protégée. Convinced that "any patron in the world would pay millions to hear her advice, even if just on the telephone," he encouraged her to found Ecart, her first company. It was 1978.

Ecart and *trace*

When Andrée Putman founded Ecart in 1978, she was inadvertently also filling a void in the history of French furniture. There was an immense disconnection between antiques, and their subsequent reproductions and the furniture being built by the great Italian manufacturers. The instigators of the revolution for the Arts Décoratifs' exhibition were long forgotten, and those of the Arts Ménagers were long overshadowed. The names Robert Mallet-Stevens, Jean-Michel Frank, Pierre Charreau, Charlotte Perriand, Eileen Gray, and Mariano Fortuny were barely recognizable anymore. Andrée Putman decided to bring them back from the oblivion to which the "all plastic" revolution had condemned them. Bolstered by the unrelenting support of Michel Guy, the friend who had housed her since her separation from her husband, Andrée decided to reproduce the objects and furniture that she loved—and that it seemed she alone remembered. After receiving praise for some of her objects by Gaudi, she soon found it necessary to have her own office and showroom. Finding a space on the rue Pavée, she introduced the first furniture to which she was able to secure the rights. This wasn't always easy. For example, Jean-Michel Frank, had no heir so she had to deal with the daughter of his associate.

Piece by piece, she acquired the rights to a veritable "1930s" collection that was more than just furniture. Lighting fixtures by Félix

Andrée Putman's desk on the rue Saint-Antoine.
The tortoise by Max Ernst never leaves her side. Behind her, a Bram van Velde.

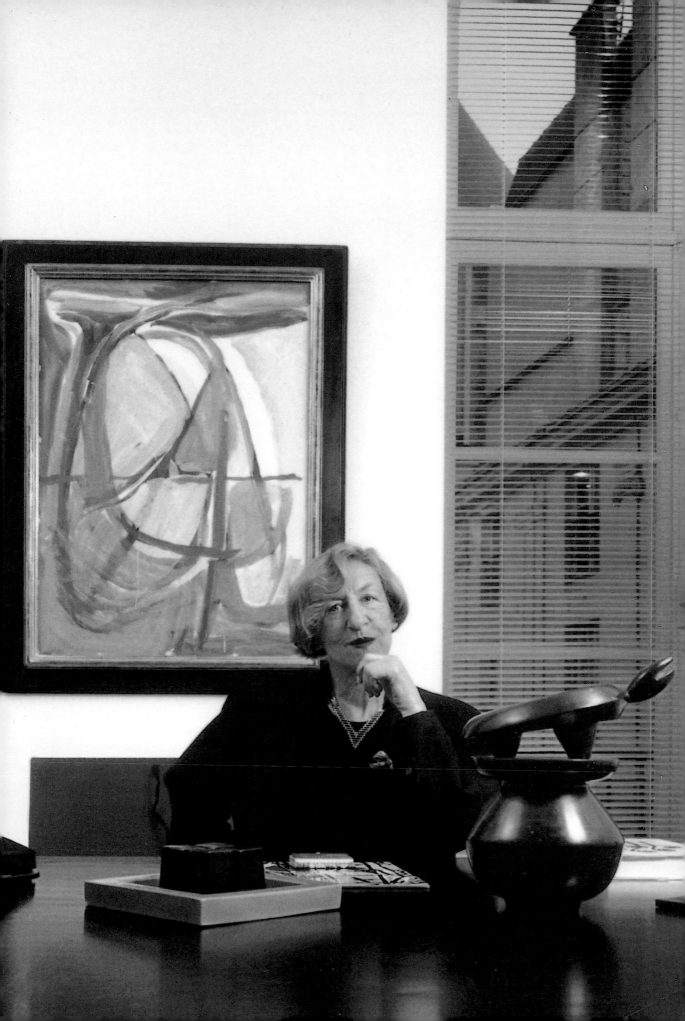

Aublet or Mariano Fortuny, the inventor of the first indirect-lighting lamps, complemented the collection that was growing on a daily basis.

Ecart also became the stage for an activity that was, at the time, never of more than secondary importance to Andrée Putman—interior design. Although she had no formal training in the field, she had agreed to take on some design jobs for her friends. In the 1960s, she advised Denise Fayolle and Maïmé Arnodin to set aside a large room in their new apartment for their bathroom. She convinced them to take pride in a room that is one of the most used by active-lifestyle people that are often away from home. She envisioned the bathtub in the middle of the room completely covered with white tiles, indulging her neurotic love of a clean composition. It was soon after this that Michel Guy entrusted her with the design of his newly acquired loft above Bernard Buffet, in Saint-Tropez. As we know, her success led this apartment to become the first in a series of five that she designed for the future minister of culture.

Practically by accident, Andrée's flair for designing became a division of Ecart International. Thierry Mugler, an acquaintance from the Créateurs et Industriels venture, commissioned her talents to design his first boutique. Didier Grumbach, the head of Yves Saint Laurent, offered her the chance to design his boutiques in the United States, plus his apartments in Paris and New York. Soon after that came the Paris Hémisphères boutique, then Karl Lagerfeld's apartments in Paris and Rome.

At this time, Andrée Putman felt she was the target of a misunderstanding worthy of Marivaud—New York, which she explored with Andy Warhol, believed her to be a famous French designer. Meanwhile Paris celebrated the American success of its native daughter. In 1984, she

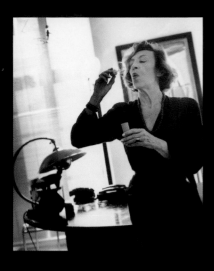

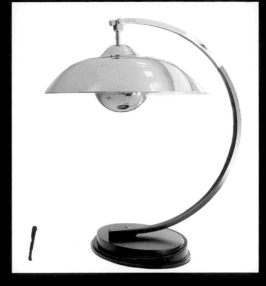

Three bubbles of light

1 Fortuny lamp
 Mariano has invented indirect
 lighting

2 umbrella standing lamp
 it could enlighten a whole room
 on it's own

3 Ball lamp by Felix Aublet

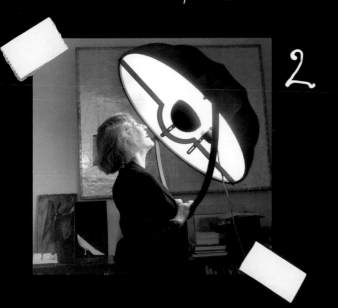

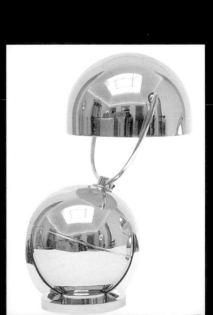

completed the two most outstanding projects of her career: the Centre d'Arts Plastiques Contemporains (CAPC) in the old Laîné warehouses in Bordeaux, and Morgans Hotel in New York for the notorious owners of Studio 54, Steve Rubell and Ian Schrager. That was all it took for the fiery Jack Lang, the minister of culture at the time, to appoint her to design his office as well—Andrée Putnam was on her way.

 "We were enchanted by certain objects that maintain their magic. I am thinking, in particular, of the paper lanterns of Noguchi. At the end of the 1950s, one of those lanterns, shaped like a pumpkin, was the object I preferred to have in my room. Some friends of my parents, narrow-minded members of the Establishment, offered their condolences to my mother for my bad taste."

The showroom of Ecart International at its prime.

44

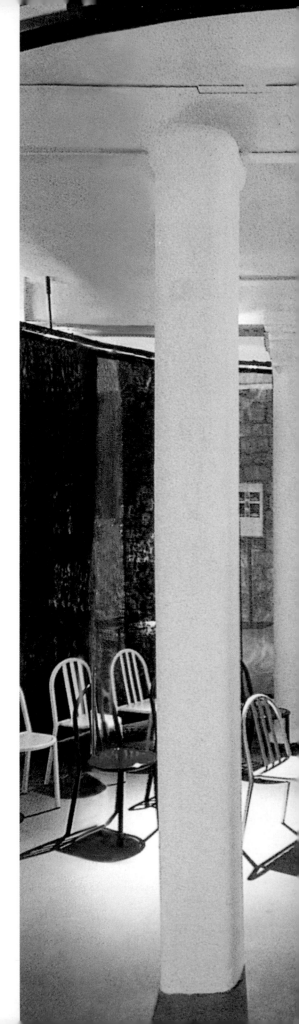

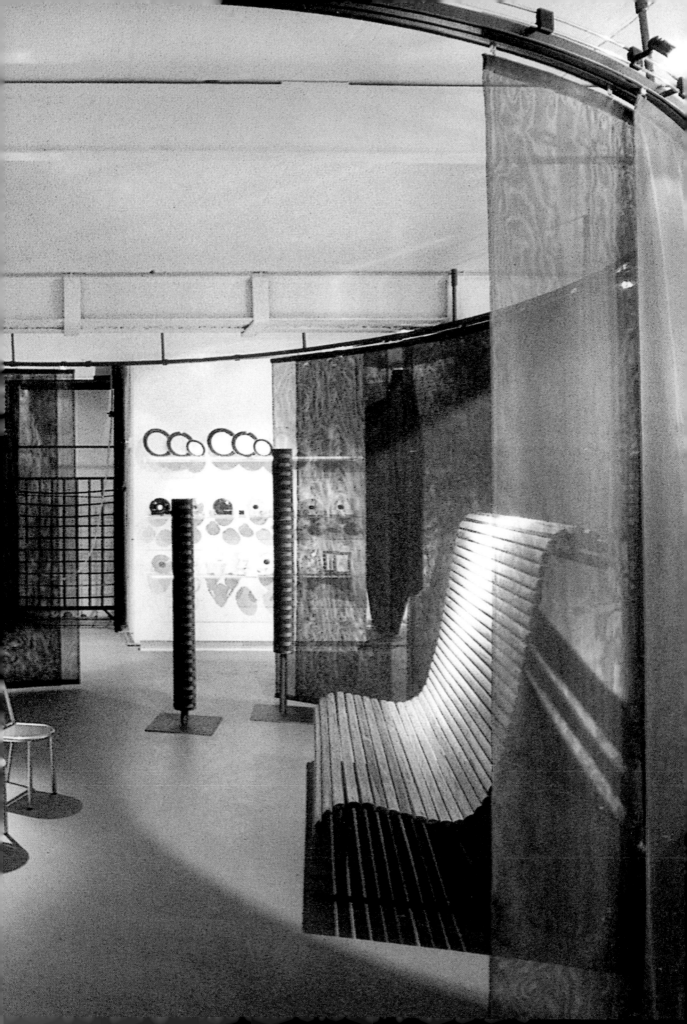

Le Palace

From top to bottom
and from left to right:
1. Alice Springs and
Andrée Putman;
2. Francesco Clemente;
3. Cyrille Putman and
his mother;
4. Andrée Putman
and Larissa;
5. Fabrice Emaer;
6. Andrée Putman
and Helmut Newton.

Opposite: Andrée Putman
and a nightlife friend,
at the Palace in Paris.

"We go out less than before, either because of too much work, or a lack of desire. When we do go out, we're happy to rediscover the fun in life, and we think of the famous words of Coco Chanel who once said 'if we dance all night, we look good.'"

Rob. Mallet-Stevens
Little chair

Creating Ecart was important to Andrée Putman because she felt a need to reincarnate the work of a generation of designers. These "grandparents of design," had been neglected with the advent of mass consumption.

With a fond memory of this funny little chair, first displayed at the Salon des Arts Ménagers, she acquired the exclusive rights to reproduce it. Her affectionate (and persistant) friend Alice Morgaine, had Nicole Bamberger finally locate the object in the home of Rob. Mallet-Stevens's granddaughter. The genius of this little chair is in its extreme simplicity that borders on barrenness. Its reintroduction was a revelation. The enthusiastic public reception confirmed its universal appeal, though this was also evidenced by the diverse places that it was found: the restaurant at the Austerlitz station, the haute couture salons of Yves Saint Laurent, the CAPC museum of contemporary art in Bordeaux, and even the Hôtel du Département des Bouches-du-Rhône.

According to Andrée Putman: "Encountering this object was one of the decisive moments of my life. Its proportions, its elegance, its appearance, make it timeless." With the heirs' permission, she designed several versions of the chair, one covered with hammered metal epoxy paint, another with a thin round of leather, and a third like a child's seat.

Revived by Ecart in 1978, the famous little chair was originally created for the Art Ménagers exhibition in 1936. Following pages: The conference room of the Conseil Général of the Bouches-du-Rhône.

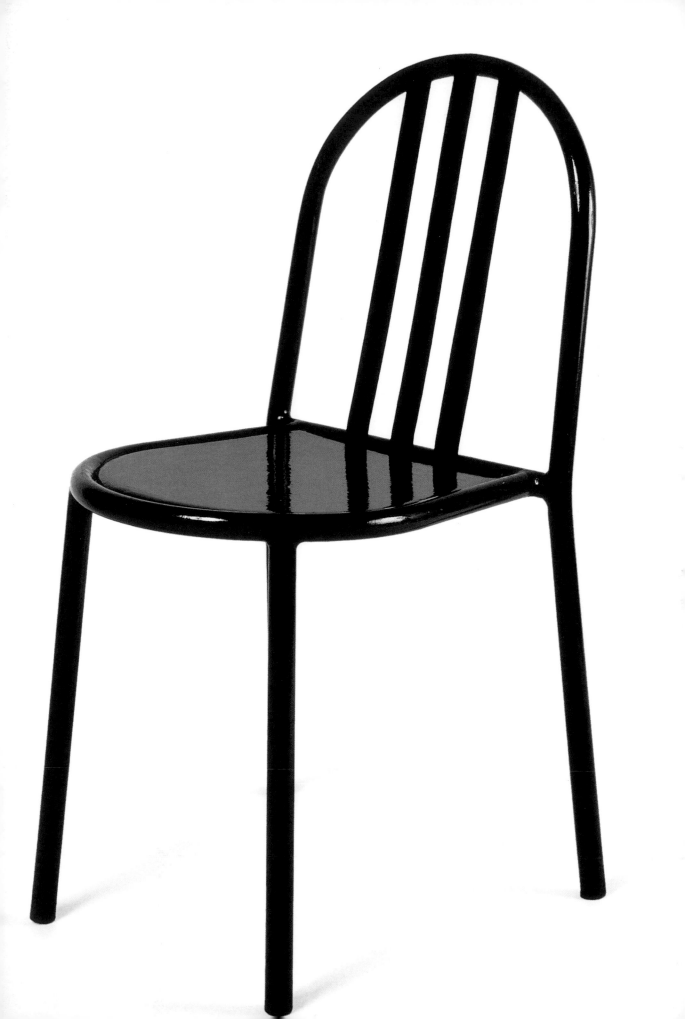

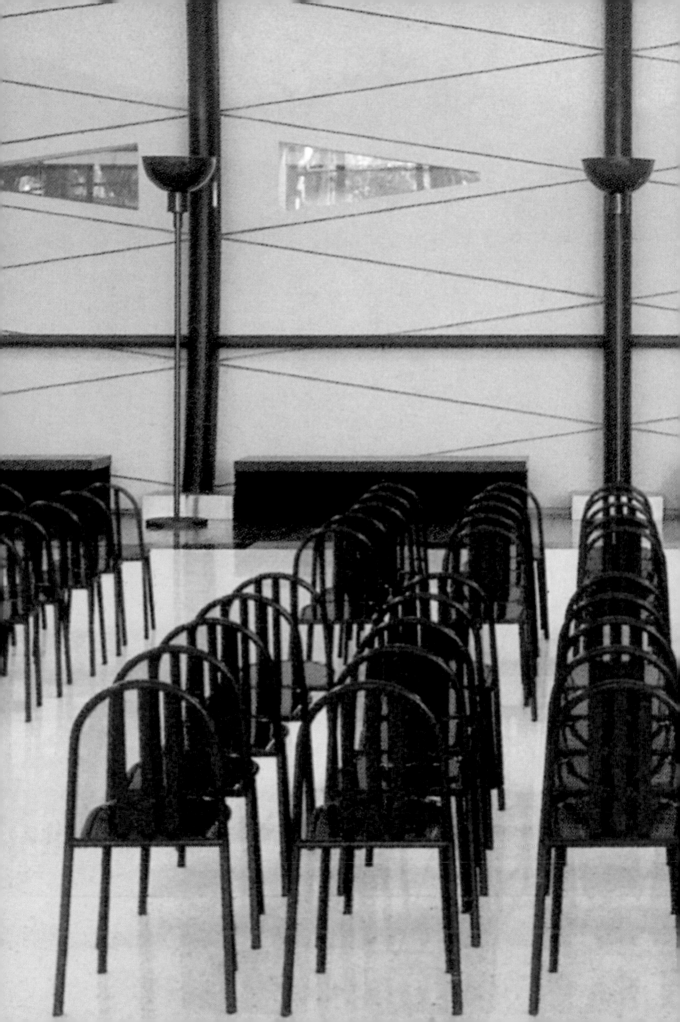

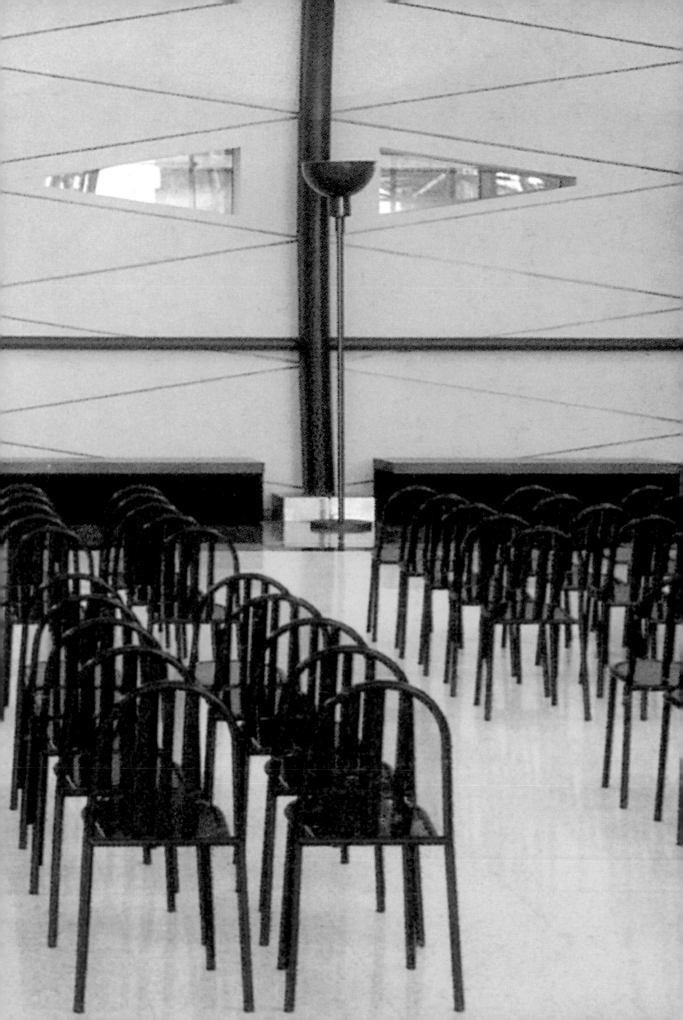

TESTIMONY

BERNARD-HENRI LÉVY
The Politics of Andrée Putman

The first time I heard Andrée Putman's name mentioned was sometime around 1985. Ecart was seven years old.

It had been two years since the Morgans Hotel in New York.

It was back when I thought that good people had good taste, and the bastards had bad taste.

It was the time when I had dared to state, in front of Putman actually, on a television program called *Le Grand échiquier*—I was responsible for the line-up on the show, and without having met her, I was terribly insistent that she be invited along with the other artists—along with Serge Gainsbourg, I think, and the painters Jacques Martinez and Pierre Soulages, and I don't remember who else, I said to her face that never would some French Fascist leader, like the one who was just starting to make the news, live with Thonet furniture, or choose a chair by Mallet-Stevens, or wear Issey Miyake.

It was the time when, in a word that sufficed to sum up, for me, this magic name of Andrée Putman, there existed, for this leader, for me, for her, for each of us, a sort of frequency or wavelength, each time remarkable and each time unique, that flowed through what we thought, did, felt, and lived and conferred on it, at the end of everything, a dark but certain unity. It was the time when I was Althusserian enough to credit the concept, though I don't know what it would mean to young readers today, of overdetermination and where this overdetermination, this idea of a 'structured coherent whole, consonant in its parts,' could, when put to the test in real life, also be called style.

I am no longer of that belief, of course.

Since way back then, sometimes, I have, however, confirmed that this world is much less well made than my Althusserian Putmanism had me believe.

But still something in me continues to believe in this magical, gratifying harmony that I would say was predetermined if I did not feel it was entirely the result of the existence of, or obviously contingent upon, a few great minds like that of Andrée Putman. I am not reconciled to the idea that things and ideas may not go hand in hand and, in this harmony, in this primitive Platonism, in my own secular version of "no man is voluntarily evil" that translates to "no one chooses ordinariness and ugliness by chance," I continue more than ever to value Andrée's image and vision.

This is to say that Andrée, I obviously haven't forgotten her, is first and foremost an artist, with all that the word implies of disinterestedness, joyfulness, and playfulness, a free artist who creates her own style and does what she pleases.

All this is to say that I also have not forgotten that Andrée's admiration always lies first with the artist. Witness the day when asked about her use of black and white, about her very Nancy Cunard love of gray, and her seeming distrust of color, she gave this magnificent, modest response: "But no! On the contrary, I love color! But I like artists too much. I have too much respect for what they will do with this house I am inventing; so by using gray, I am reserving the use of color exclusively for them!"

But to say that, yes, this artist has her politics. That the birth and, today, the triumph of her joyful minimalism, her poetry of space and lines, her extreme geography, her bold blend of lines and materials, also tells us something about the contemporary democratic spirit meant in the best possible sense.

The Putman of Ecart—which, as we know, can also be read backwards as *Trace*.

The Putman whose creations (although it goes without saying), it should be said, have contributed to the reinvention of contemporary life.

The Putman of the grand reeditions who finally, a few years after a writer—and what a writer!—familiarized us with her fine ideas of culture for all and new cathedrals of knowledge, devoted herself with the means available to her in making the eternal forms of art coincide with the desire and especially, in the use of the many.

The incredibly poetic Putman, the waking dreamer, iconoclast, and iconophile, who is in love with both her time and timeless ideals, an artist and activist who, having become a designer for Prisunic, dared to ask Alechinsky to illustrate the homemaker's almanac and Messagier to design some printed fabrics. The Putman who, as interested in today's literature as she is in painting or music, searches for the true line as others search for the right word, is in the process of making her exquisite houses and the landscape that she molds and transforms into a quoting machine, therefore recycle, therefore revive, therefore, once again, bring to the same level as all the writings that inspire her. Our conversations in Tangiers, with Benoît Jacquot and Mathieu Tarot.

Her willingness to combine the tangible exuberance of the place with her minimalism and her love of sparseness that does not equate a quest for purity.

The way she respects the character of a place with all the prodigious cosmopolitanism of the city of Beckett, Bowles, and Choukri without surrendering to the circumstances that dictated her own history, or mine.

And then the day she announced, as though it were perfectly obvious, that she couldn't stand decorators and worked, basically, as a portrait artist. Of whom, dear God? Of those who will live in the place? Of the city where the place is? Those that are in the city, or on the contrary, the city that is in them? Well, there you have it. It's all there. The cryptic politics of Andrée Putman.

Eileen Gray

As a teenager, Andrée Putman discovered some art deco magazines featuring the creations of decorative artists, in the secondhand book stands along the banks of the Seine. She was particularly drawn to the work of Eileen Gray, even though it was censured by the critics. Headline articles about the "atrocious proposals of Miss Gray," whom they called "the sister of Dr. Caligari," did not dissuade her.

Her surgical-like precision of details, and the ease in which she handled new materials such as perforated steel, fascinated Andrée. But she was just as fascinated by the unapologetic casualness of some of Gray's creations, like the little table that disappeared by sliding it under a bed.

Story has it that these two revolutionary designers, Andrée Putman and Eileen Gray, never met. En route from her apartment on the rue Bonaparte to their rendezvous on rue de Rennes where Andrée was the art director for Créateurs et Industriels, Gray noticed a run in one of her stockings. Out of respect for the prestigious woman she was going to meet, she decided to go home and change. The meeting was postponed. Eileen Gray died of a bad cold a few days later.

Eileen Gray was the first artist that Andrée Putman decided to reproduce with Ecart. The carpets, the chests of drawers, a black armchair, and especially the Satellite mirror, are some of the most impressive pieces of her completed career.

The Satellite mirror/lamp of Eileen Gray, 1927, created for the villa E-1027, reissued by Andrée Putman.

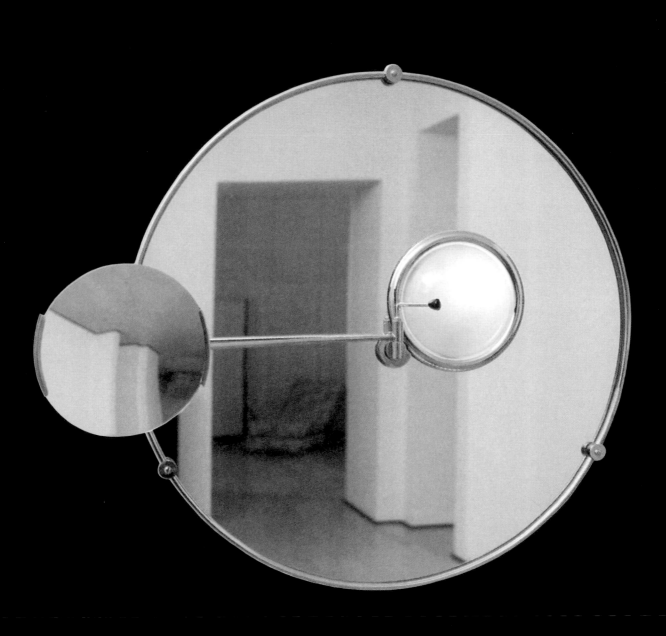

Furniture and rug by Eileen Gray, reissued by Andrée Putman.

The first chosen ones
Eileen Gray

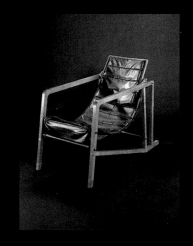

"The piece of furniture I will never part with."

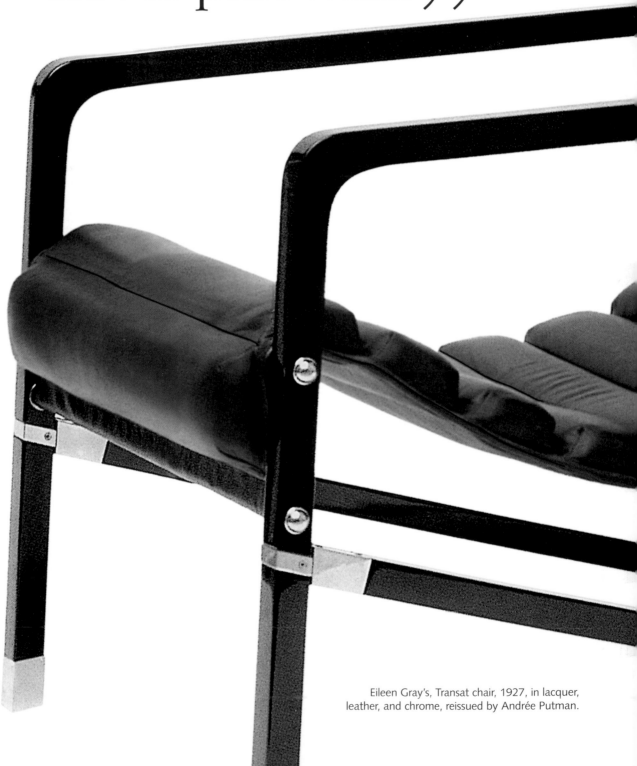

Eileen Gray's, Transat chair, 1927, in lacquer, leather, and chrome, reissued by Andrée Putman.

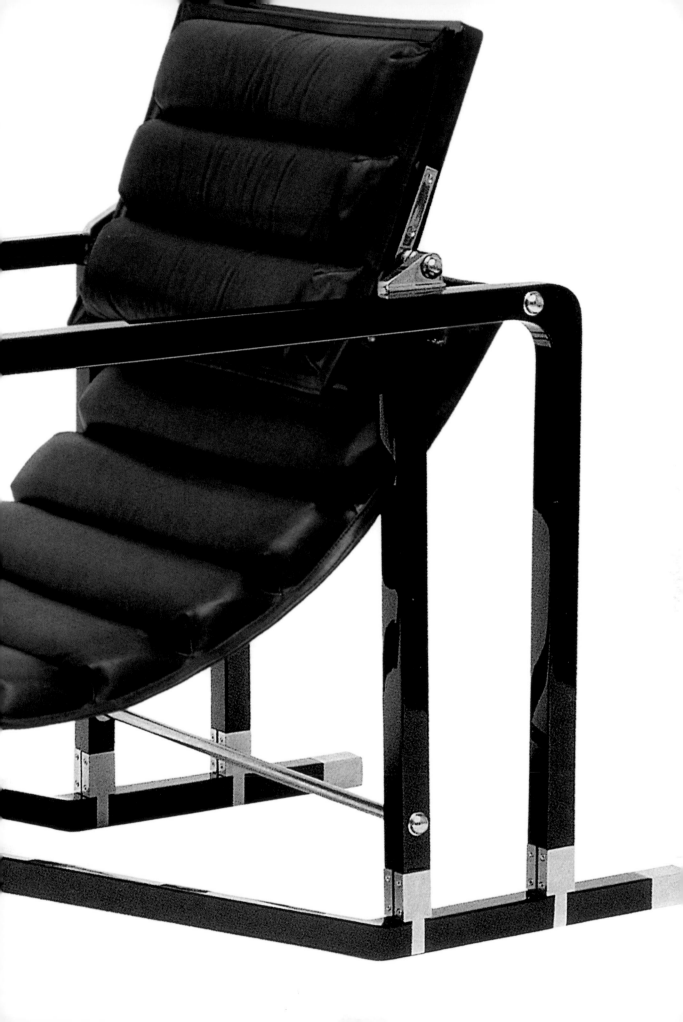

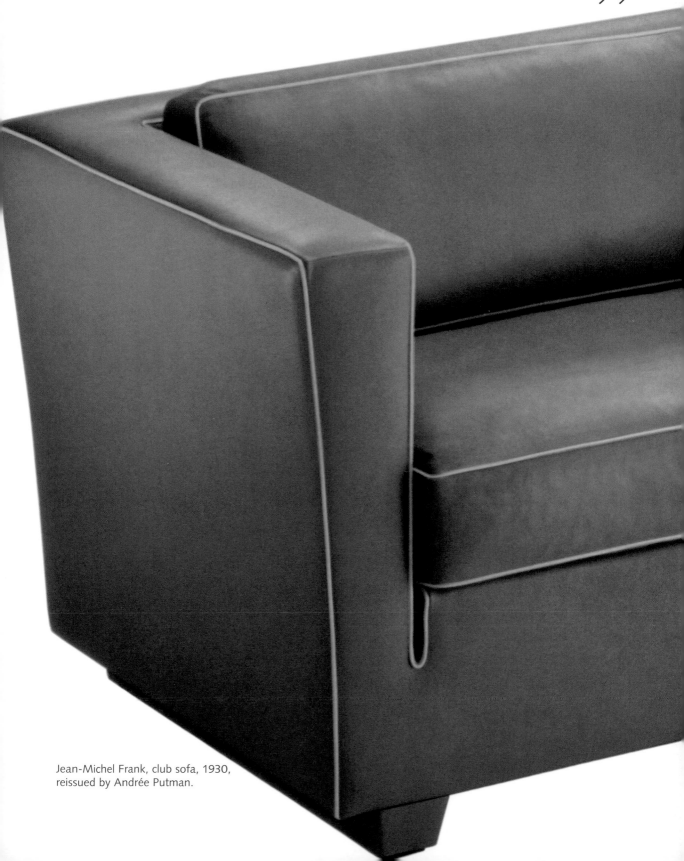

"Rarely has such natural expression proven so clever. Jean-Michel Frank reveals himself, doing it differently; he is beyond taste. His pessimistic ghost haunted his era."

Jean-Michel Frank, club sofa, 1930, reissued by Andrée Putman.

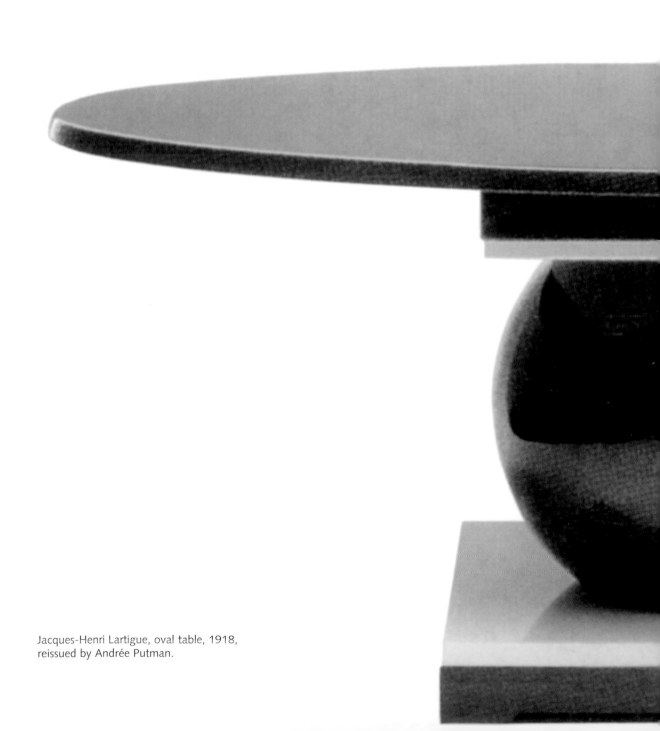

Jacques-Henri Lartigue, oval table, 1918,
reissued by Andrée Putman.

“ Black has always been a synonym for luxury, but the oil spill—sorry, I didn't mean to bring it up—the oil spill of the 80s made it common. For me, a black leather sofa so completely vulgarizes a magnificent color, I find it unbearable. A living room full of black leather with two club chairs facing the sofa—that's what killed black. ”

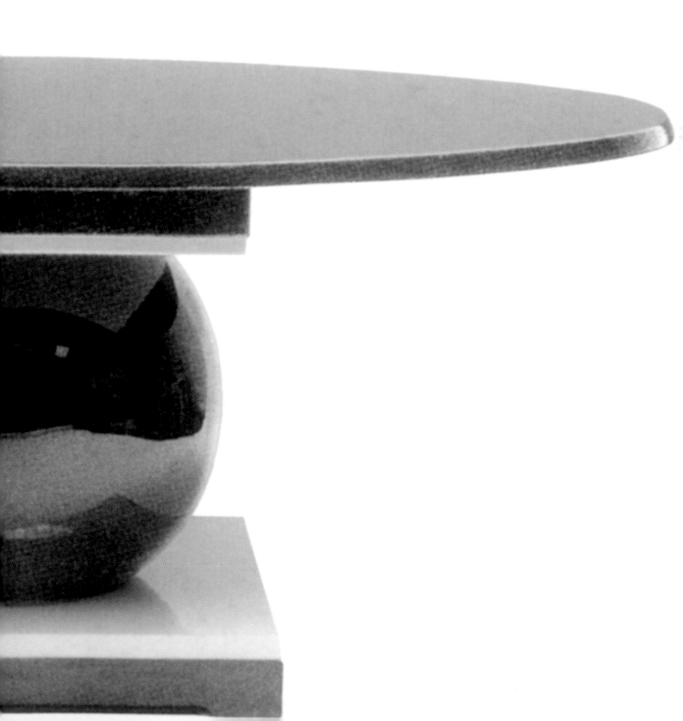

The *appointed* Artist

It is a long shot to call Andrée Putman the "appointed" artist. While these days there is rarely a formal ceremony in her honor where Andrée Putman is not described as the ambassador of French style and design, this has not always been the case. An outcast of her social class, Putman always criticized the French passion for "good taste," too often a synonym for gold-leaf trimming and wood paneling. In Jack Lang's words: "She had the rebellious spirit of the grandes dames suffocating under gilt and stucco and creating a scandal by scothing that good taste did not exist." (Andrée Putman, éditions Pyramyd, 2003, translation.)

All the same Jack Lang suggested in 1983 that Andrée design his office at the Ministry of Culture as part of a government initiative to promote contemporary French artists. Enjoying the support of François Mitterand as well, many architects and designers benefited from these new government orders.

There is a story behind this first government "appointed" commission. In 1988, after the first cohabitation, the term used to define a ruling president and prime minister from different parties, the office's desk was returned to the rue de Valois. In 1997, Lionel Jospin, newly appointed by Jacques Chirac as prime minister, decided to have it moved to the Matignon Hotel. The unique piece of furniture stayed there until the arrival of Jean-Pierre Raffarin, the prime minister in 2002, who decided

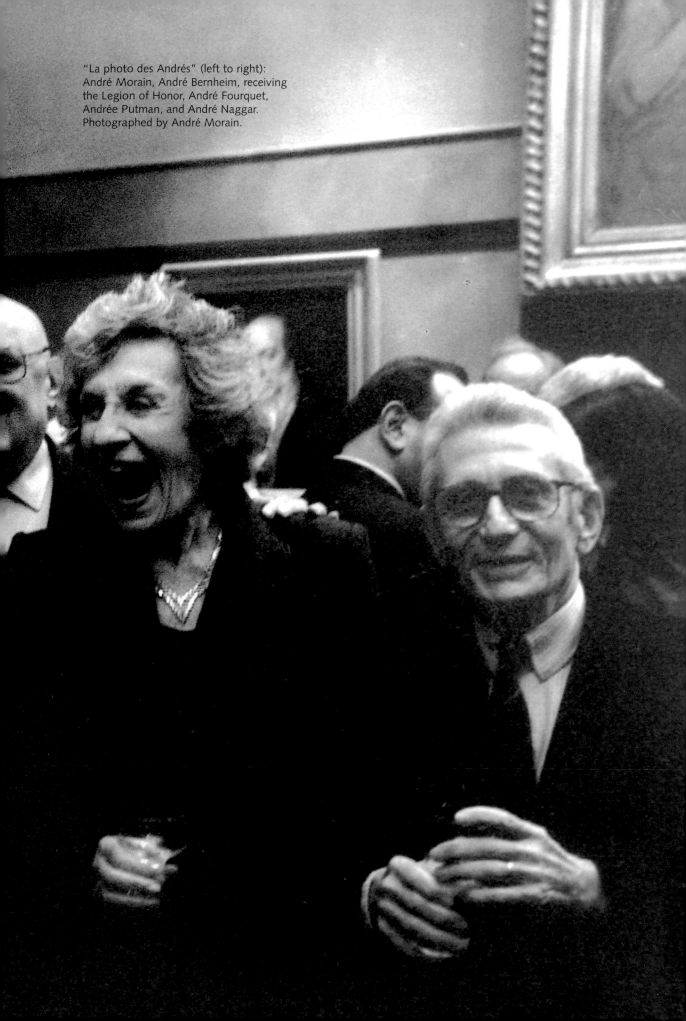

"La photo des Andrés" (left to right):
André Morain, André Bernheim, receiving
the Legion of Honor, André Fourquet,
Andrée Putman, and André Naggar.
Photographed by André Morain.

2

Four pictures of the Museum of fine Arts in Rouen

3

4

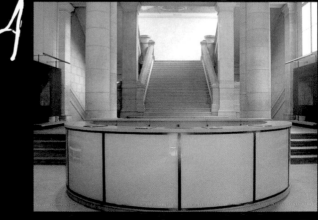

to enhance it with a pair of matching shelves, which Andrée Putman designed. At the same time, Jack Lang, appointed in 1999 as national education minister, once again appealed to Andrée Putman, this time to redo his new offices. The project was finished just before Jacques Chirac's reelection.

But the first commission ordered by Jack Lang paved the way for several public buildings to benefit from the Putman touch. Her talents enhanced the Musée des Beaux-Arts de Rouen; two of the four ministerial offices of the Ministry of Finance in Bercy; the top floors of the Arche de la Défense, built for the Summit of Industrialized Countries in 1989; and the French Pavilion at the World Fair in Seville in 1992. In 1987, Putman finished the offices of the Hôtel de Région de Bordeaux for Jacques Chaban-Delmas. In 1993, the General Council of Bouches-du-Rhône commissioned her. And in 2004, she was chosen to complete a project consisting of tens of thousands of square feet for the General Council of Deux-Sèvres, in Niort.

Like her grandfather Edouard Aynard, president of the Chamber of Deputies, who died of apoplexy in the middle of an administrative session, Andrée's destiny has been bound to power. Despite her success, neither her views nor her designs have become elitist.

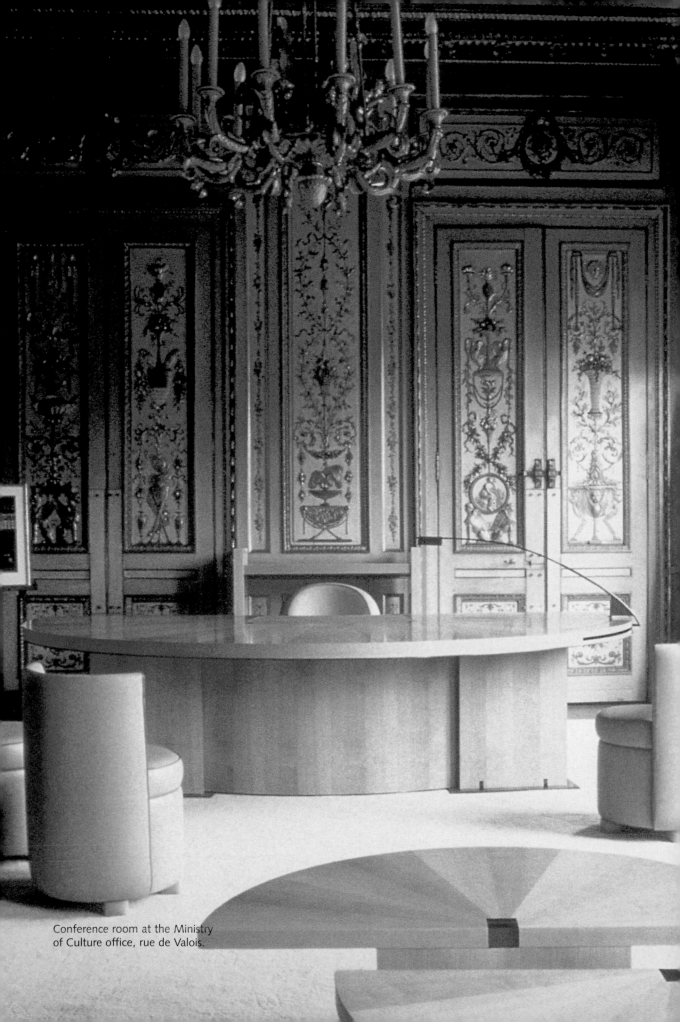

Conference room at the Ministry
of Culture office, rue de Valois.

TESTIMONY

JACK LANG

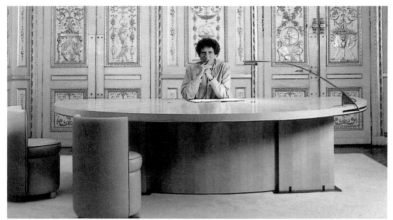

Jack Lang at his desk, 1985.

When did Andrée Putman work for you for the first time?

It was in 1984, while implementing a policy strategized to give contemporary artists a place in society with government sponsored commissions. François Mitterrand and myself felt that the president of the republic and the ministers should set the example for this reconciliation between art and society. After charging Philippe Stark and Jean-Michel Wilmotte with the renovation of the Elysée living quarters, it was my duty as minister of culture to be an example. So I had Pierre Alechinsky design a room on rue de Valois, commisioned Buren because of his famous colonnade at the Palais Royal, Pol Bury for the fountains. It is quite common to also hire a designer when creating a desk. Andrée Putman has a great respect for the interior; I knew she was the obvious choice.

How did you discover her work?

She was already famous at the time and her work was highly regarded.

Did you feel it was your duty, as the French minister of culture, to promote a "French school" of design?

We succeeded in creating a movement that rehabilitated design and contemporary art, and reconciled them with government. We also succeeded in getting manufacturers and designers to work together. The state was the driving force to make that happen. We launched several national competitions to replace the furniture and lighting in the ministries and public institutions. Unfortunately, conservatism has since come galloping back.

Tell us the story behind that first desk.

The first miracle was that it wasn't moved during the first cohabitation, unlike most other pieces. But occupying the office does not necessarily mean one should openly question some of the most popular works—it would have looked bad in the public eye. So I found my desk intact in 1988. One evening, the young minister of education of the time, Lionel Jospin, was passing by the handsome desk and he stopped short in front of it. So, it was soon transferred to the rue de Grenelle. Three years later, I succeeded him in that position, and got my desk back. In 1997, when Lionel Jospin became prime minister, the desk was in limbo at the Mobilier National. I believe the current prime minister is still using it today. It is a rare example of a work of exceptional longevity, surviving ministerial quirks along the way. To me, it embodies a bold, respectful woman, who incorporated the spirit of today with a history she held in high regard.

And you commisioned her when you were appointed national education minister?

When I found myself back on the rue de Grenelle in 2000, I discovered a ministry that frankly, was hideous. It felt like I had just entered an abandoned summer house. It was truly depressing. We started renovating the inside and the outside. I asked Andrée Putman to design a large portion including the waiting and reception rooms, and the ministerial offices. The work she did there has never been sufficiently heralded. I believe my immediate successor had little appreciation for the outstanding quality of these creations. Visitors and especially staff were overjoyed with the new premises and their greatly improved living conditions. Before the changes, the reception area on the ground floor felt like part of a permanent blizzard in wintertime as the wind and rain would blow inside every time the door opened. Andrée Putman designed an elegant double-door system and a spacious reception desk, restoring a feeling of serenity to a place without any. It is a masterpiece of beauty and respect, for the space of course, but above all for the people who used this space.

In your opinion, what role did Andrée Putman play in French design?

The Japanese would call her a *Ningen Kokuhô*, a living national treasure. Andrée Putman is herself a work of art— her elegance, her distinction, and her manner—the exterior qualities, that are in perfect harmony with her inner qualities—sensitivity, respect, tenderness, and a fervent love of life. She is an extraordinary ambassador thus her work can be visibly exported. She represents the France that I love and am proud of. She personifies France, of what our country should be, a combination of history, culture, and innovation. Andrée Putman is at the juncture where these intense movements converge. She is "Andrée la France."

You have called her the "muse of timelessness."

She is steeped in history, culture, liberty, but at the same time she is life. Nourished by history and culture, her work is profound. But at the same time, she is filled with a creative boldness that transcends ephemeral trends.

How would you define the "Putman style"?

Precision and softness, precision and warmth, precision and harmony.

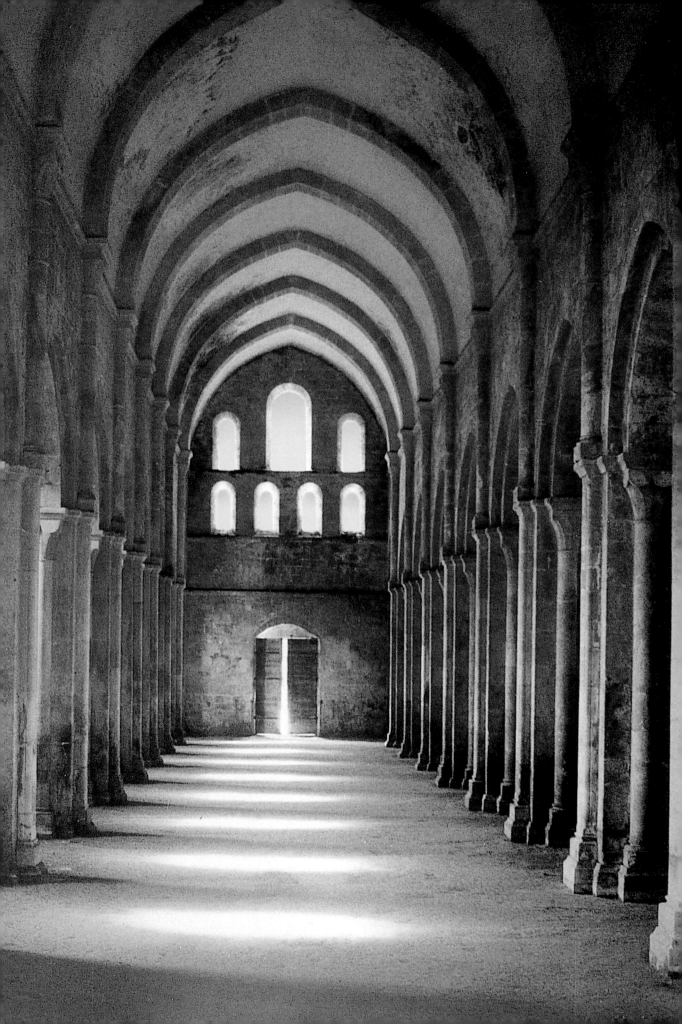

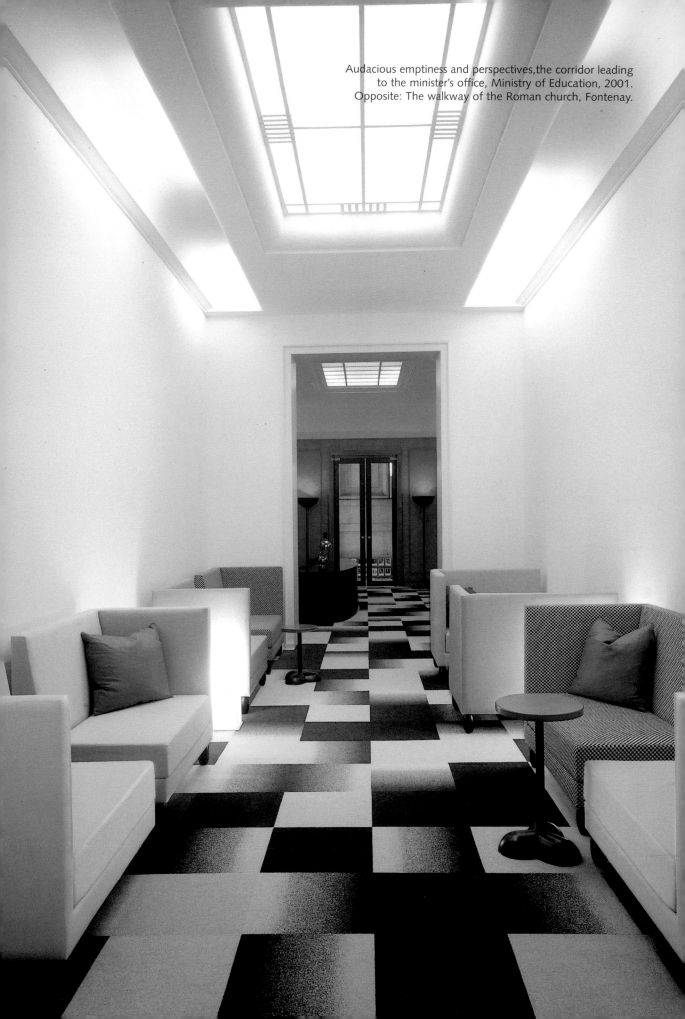

Audacious emptiness and perspectives, the corridor leading
to the minister's office, Ministry of Education, 2001.
Opposite: The walkway of the Roman church, Fontenay.

Alter lamp (in the shape of a
dumbbell), Andrée Putman editions.
Opposite: Corridor of the CAPC,
Bordeaux, 1986.

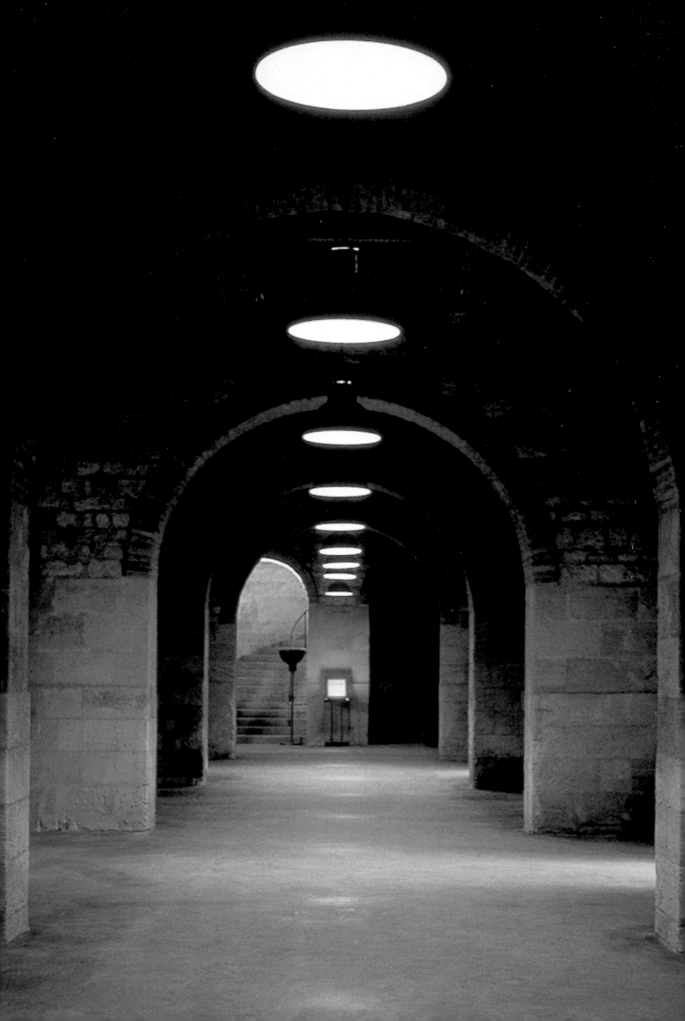

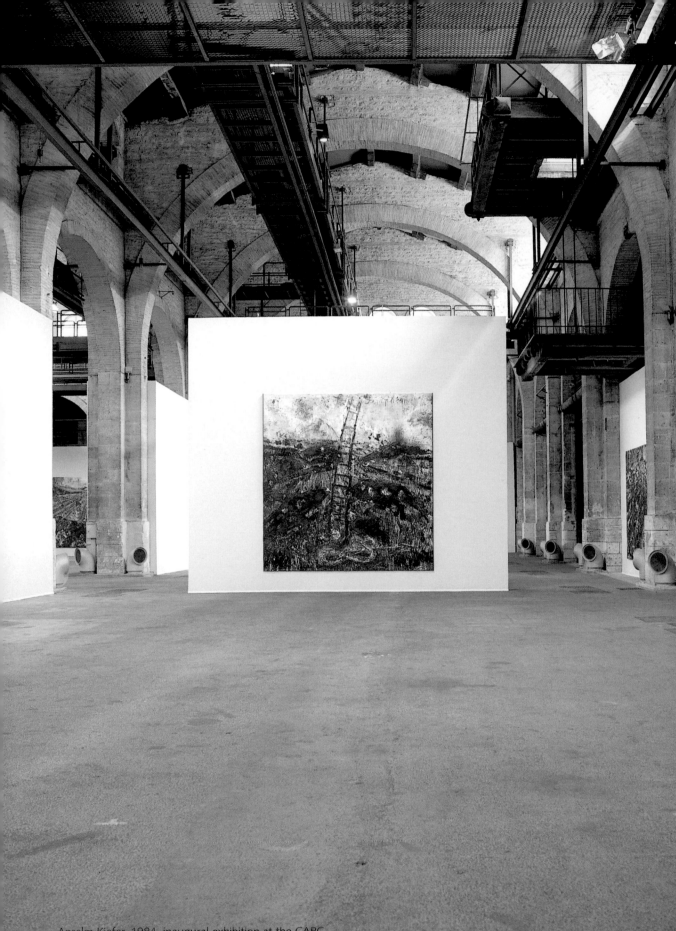

Anselm Kiefer, 1984, inaugural exhibition at the CAPC.
Following pages: Orientation tables at the CAPC, Bordeaux.

TESTIMONY
JEAN-LOUIS FROMENT

What made you think of suggesting Andrée Putman for the restoration of the Laîné warehouses in Bordeaux?

In 1969, I was invited to meet Jacques Putman at his house on the quai des Grands-Augustins. Andrée wasn't there, I didn't know who she was, but I found the place to always remain a fantasy for me. I've often tried to relive the metamorphosis of emotions that I felt during this visit. I will always carry these images with me.

About ten years later, I actually met Andrée Putman during a Robert Wilson exhibition. Later there was the lunch where I asked her to come see the Laîné warehouse, the place that would become the CAPC museum of contemporary art.

How did your first work meeting go? I have heard a story about the smell of spices that Andrée was able to detect and identify...

It's true. But what I remember best was that Laîné's outer doors were blue, which I would later learn was Andrée's favorite color. She used to always have a collection of ballpoint blue-topped pens on her desk. She told me she was going to bring this blue into the museum. I also believe that the warehouse reminded her of strolls through Fontenay during her childhood.

From the stories I have heard from the project site it seems that the collaboration was entertaining and far from conventional.

Andrée may be very interested in the language of tradition, but her approach is not in the least bit traditional. In her work she transcends that which is just required. Since I was not the museum curator, and the Mayor of Bordeaux, Jacques Chaban-Delmas, gave me a lot of freedom, I would venture to say that we were both "out of order." But that end result was our motivation.

How did you find the final result to be, compared with what you had envisioned?

My great surprise, when all was said and done, was how incredibly unassuming the décor was throughout, and moreover so necessary for the arranged works as well.

What did you learn from this collaboration?

There was, before and after, Andrée Putman. There was the huge obligation and the meticulousness that allowed the words from the language to become the shaping of language. There was also loyalty, along with a thirst for adversity. But I'm also a bit upset with Andrée Putman for having educated my taste, my views. Life is more difficult when you can tell what is beautiful from what isn't.

What was the impact, at the time, of the CAPC built by Andrée Putman?

It was in stages, driven by the rising curve of recognition for Andrée's work. It was also the first museum in an old building renovated by a famous designer. Today there are several of them, for better or for worse.

The CAPC was Andrée Putman's first museum job, before the musée des Beaux-Arts de Rouen and its set designs, then for her personal exhibitions in South America and China, to name a few. Do you think of Andrée Putman as the "Appointed Artist"?

No! The CAPC was never part of official appointments. It is true though, that politics are not discernable without something to help them shine. Jack Lang's insight on the subject is historic.

How would you describe the Andrée Putman style?

It's more something to reference than a defined school of thought, a very abstract state of mind related to her person and her appearance. Andrée Putman has ascended the ranks of mythical women. Her absolute individuality is the result of her distinct alchemy. She is reaping the rewards of her risk taking.

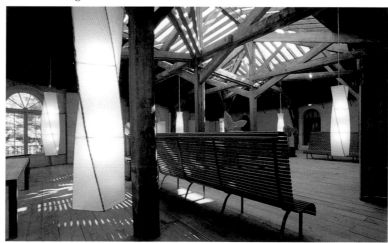

At the CAPC, silent homage to the Asianism of Marguerite Duras.

Exposition-dossier Montaigne
Librairie
Audiovisuels
Documentation-bibliothèque
Vestiaires

New York
Temptation

Andrée Putman began her conquest of New York with Didier Grumbach. He entrusted her with several projects, including his own apartment and the Yves Saint Laurent boutiques that he headed. She also designed the ground floor of the legendary department store Barneys New York. Americans assumed she was famous in Paris, and the French were enthusiastic about her American success. This double confusion actually accelerated recognition of her work.

But it was one telephone call that threw everything for a loop. In an airport lounge, a loudspeaker announced that Andrée Putman had a phone call. She lifted the telephone receiver. Steve Rubell and Ian Schrager, recently released from prison after the sensational collapse of Studio 54, were calling to offer her a hotel project. They still needed to raise money, but arranged to meet Andrée at a later date. Six months later she returned to New York to discover a most unattractive building on Madison Avenue. Amused by what she took for a student prank, Andrée snickered, "Would you please be serious? Show me the hotel now!" With dawning horror, Andrée realized she was standing in front of it. She started to meander the rooms still occupied by dealers and pimps. In the end, however, the entrepreneurs' enthusiasm won out over her reluctance. Eventually convinced that this project was futuristic, she threw herself into renovating the hotel, which did not close during their work. Rubell and Schrager were extremely open to her ideas, allowing her total

Andrée Putman in front of the Statue of Liberty, in the 1980s.

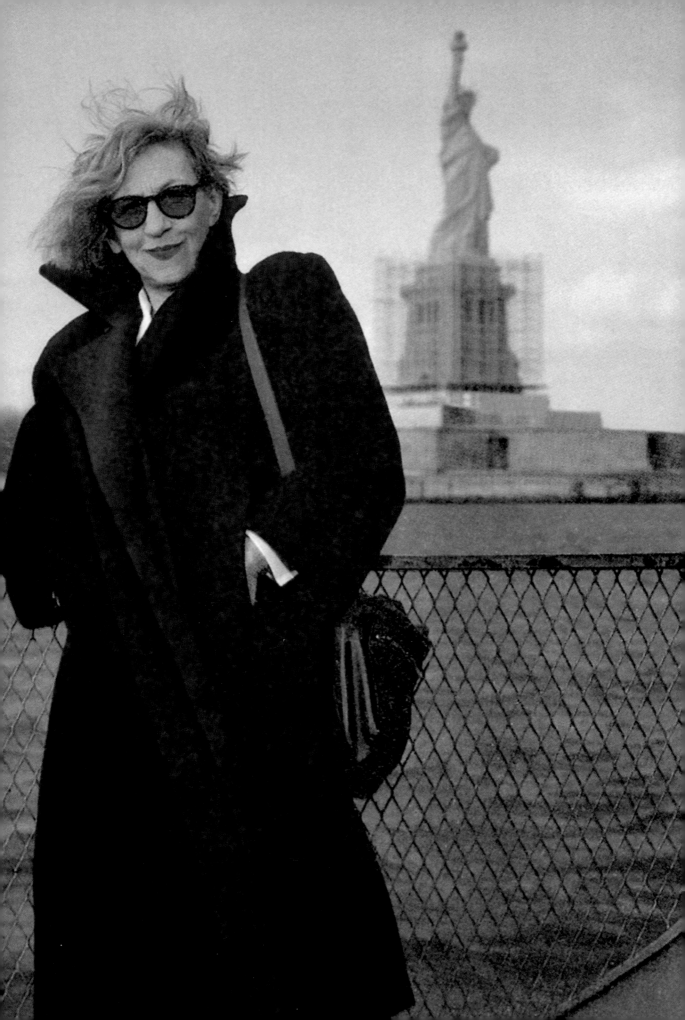

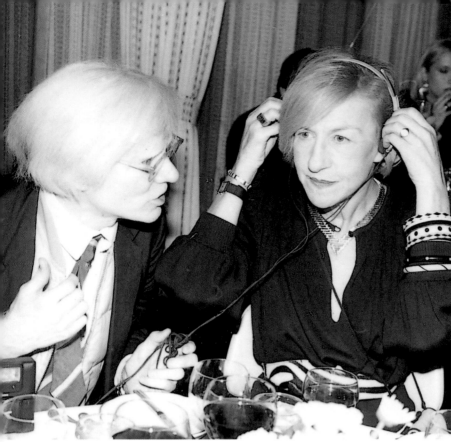
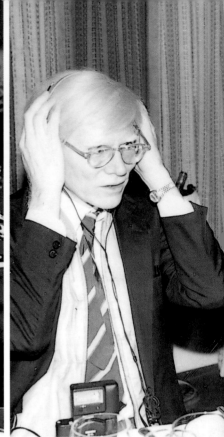

A "dialogue of the deaf" between Andy Warhol and Andrée Putman.

freedom; she would use it to marvelous advantage. During her frequent visits to New York, Andrée found a circle of friends. In the fashionable restaurant Mr. Chow, owned by Tina and Michael Chow, she met Andy Warhol and his friend Jay Johnson, his twin brother Jade, George Condo, Julian Schnabel, and Keith Haring (who had already come to meet her at Ecart, in Paris). She became friends with Larissa, an icon of the avant-garde who created stage costumes for Mick Jagger and Miles Davis. She met up with Philip Glass and Robert Wilson, friends she had first met with Michel Guy at the Avignon festival première of *Einstein on the Beach*. Guy also introduced her to Merce Cunningham and Patti Smith.

But the person Andrée was most impatient to see again was the enigmatic young photographer Robert Mapplethorpe. During a previous meeting at

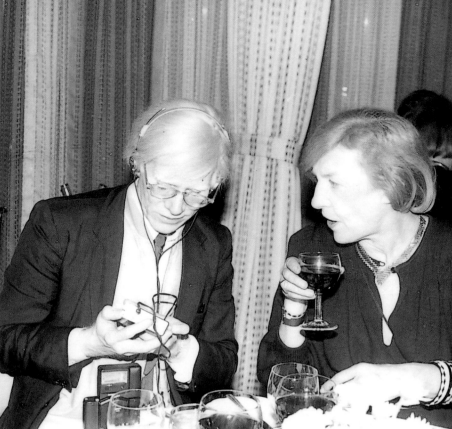

Following page : Louise Bourgeois in the 1980s.

Loulou de La Falaise's place, she was struck by his extraordinary beauty and courtesy. Moreover, they had a lot in common as Andrée related to his passion for objects, their staging, and arrangement in clusters.

She became a regular at the Mud Club, where she would take her son, Cyrille, and she would meet up with friends at Studio 54. Andrée went to CBGB with Louise Bourgeois who used to hide a bottle of whisky under her Burberry trench. At the Palladium, she met Basquiat.

With her attractive appearance, her outspoken nature and her visonary views on the decompartmentalization of design, Andrée Putman's personality quickly became known. In Fernando Sanchez's kitchen, she encountered Diana Vreeland, who convinced her to attend an avant-garde film festival at Columbia with some friends. Andrée's jet-set lifestyle was just beginning.

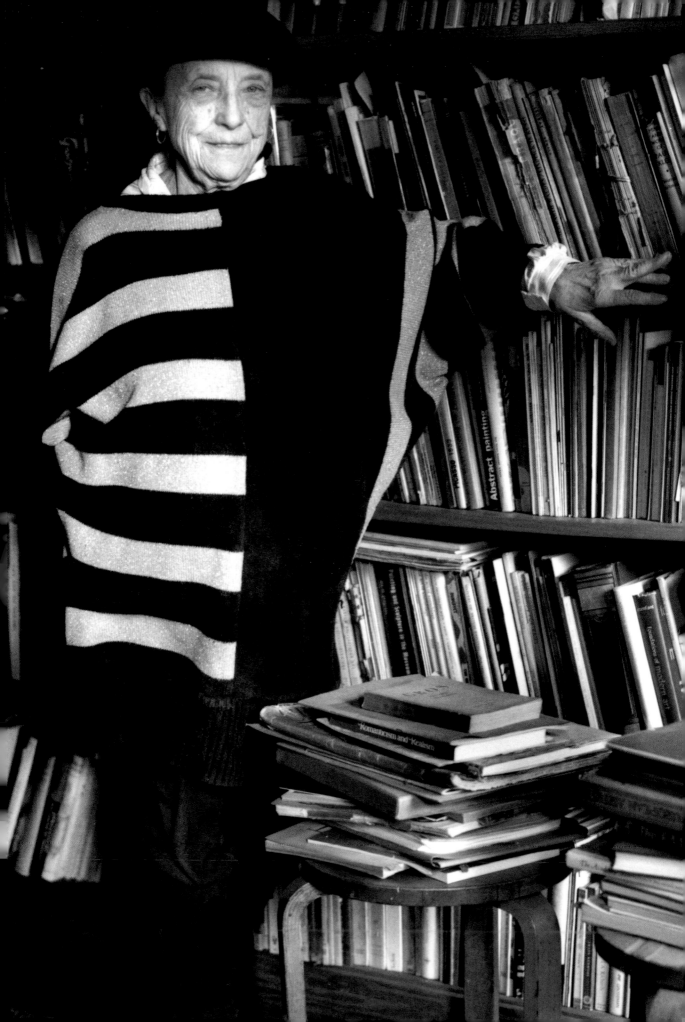

TESTIMONY

LOUISE BOURGEOIS

On the radio station France Inter "Après dissipation des brumes matinales" (after the early morning fog has lifted), on August 18, 2002, Louise Bourgeois and Andrée Putman had a telephone conversation. Andrée is in Paris and Louise in New York.

Louise Bourgeois: Andrée Putman, I always recognize her by her voice. I am very sensitive to different voices, because I listen to the radio, and I can recognize people by their intonation. She has a husky voice and she smokes like a chimney! She smokes non-stop and you can hear it in her voice.

Andrée Putman: That's just the after effects, Louise. I haven't smoked in nine years.

LB: That's funny, then.

AP: But your voice during my mornings is a wonderful gift. I can't believe it! It's part of the magic of today.

LB: That's right.

AP: What time is it?

LB: It is two o'clock in the morning.

AP: And you're not upset, to be woken up like this?

LB: I'm immensely pleased.

AP: This is perfect! I was hoping to come see you one Sunday in October.

LB: You know, that means a lot to me. And I entertain every Sunday.

AP: But there was a time in my life that I also got to see you during the week.

LB: That's right.

AP: Do you remember that wonderful nightclub, where we used to listen to …

LB: …it was called CBGB.

AP: I was talking about it a few days ago. Remember how we used to bring our own whisky?

LB: Of course.

AP: Because we didn't like the brands they served.

BL: It didn't matter to me, I don't drink at all.

AP: Neither do I. It was all a big misunderstanding! We were just trying to be prepared, just in case.

LB: That's right. The nightlife in New York was marvelous.

AP: That's no longer the case. Do you remember taking me to that place, one Sunday afternoon, where we listened to poetry?

LB: Yeah, that's right.

AP: You know yesterday, I needed a little lift so, I listened to your song "Lotte." Are you still there?

LB: I'm very here.

AP: Are you going to Berne, for the retrospective dedicated to you?

LB: No, I don't go galavanting around anymore.

AP: Except in your head perhaps.

LB: That's right.

AP: I'll come and see you in October.

LB: I'll be very here.

AP: That's the beginning of a song …

LB: That's right.

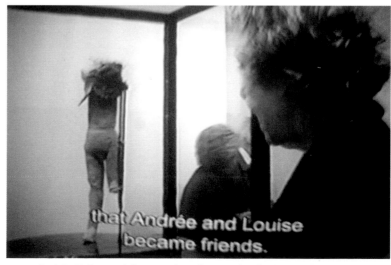

that Andrée and Louise became friends.

Andrée Putman at the opening of a creation by Louise Bourgeois, the Pièce Unique gallery in Paris.

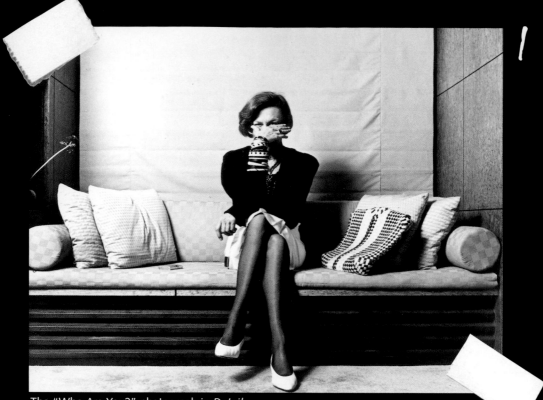

The "Who Are You?" photograph in Details.

I was recognized immediately
because of the black satin stockings
the black an white ivory jewelry
the broad shoulders and the Morgans

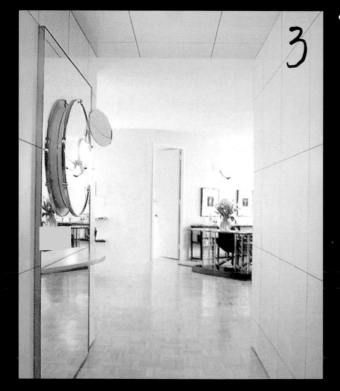

2-3: Apartment model at United Nations Plaza, New York, 1985.

66 I remember the first
time I was asked for
my autograph. It was
in New York. A cyclist—
a messenger—got
off his bike, held a
notebook out to me, and
told me: 'Miss Putman,
I love your work.' 99

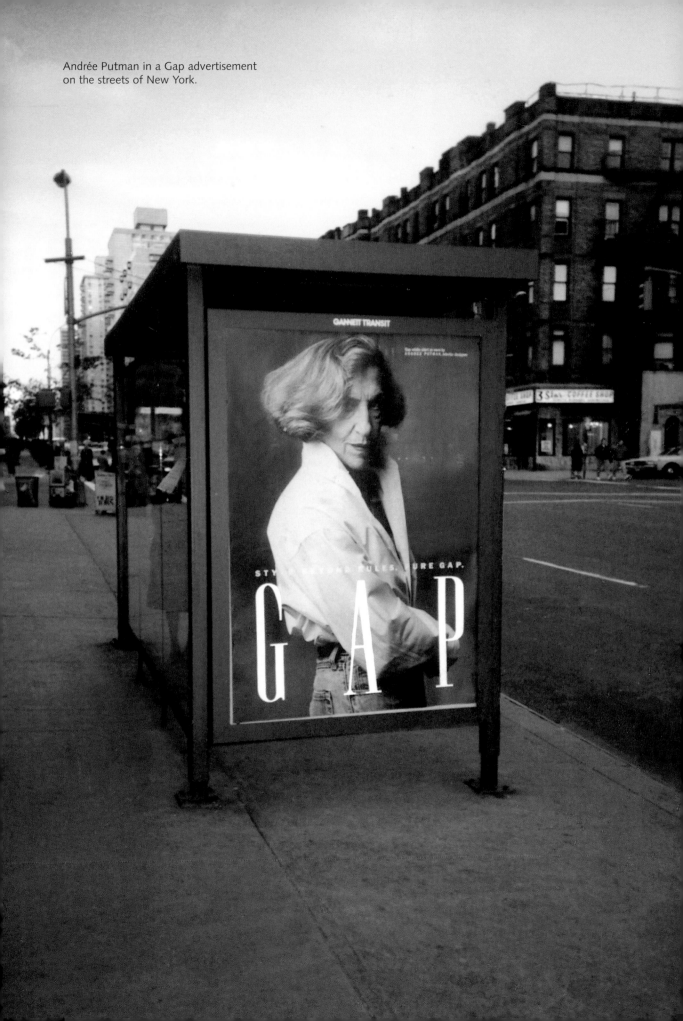

Andrée Putman in a Gap advertisement
on the streets of New York.

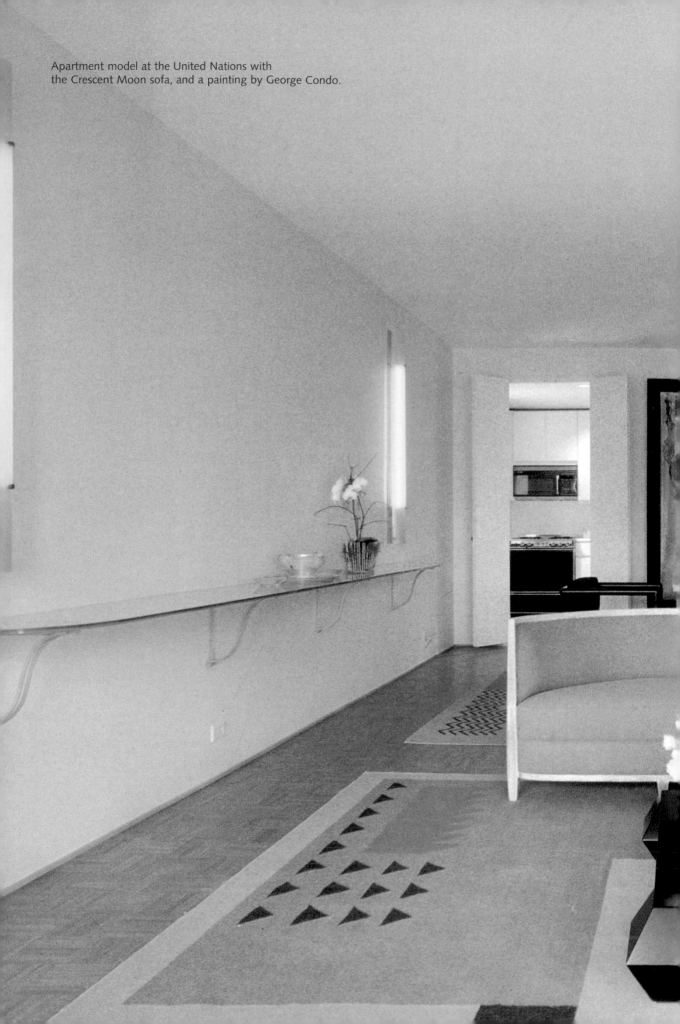

Apartment model at the United Nations with
the Crescent Moon sofa, and a painting by George Condo.

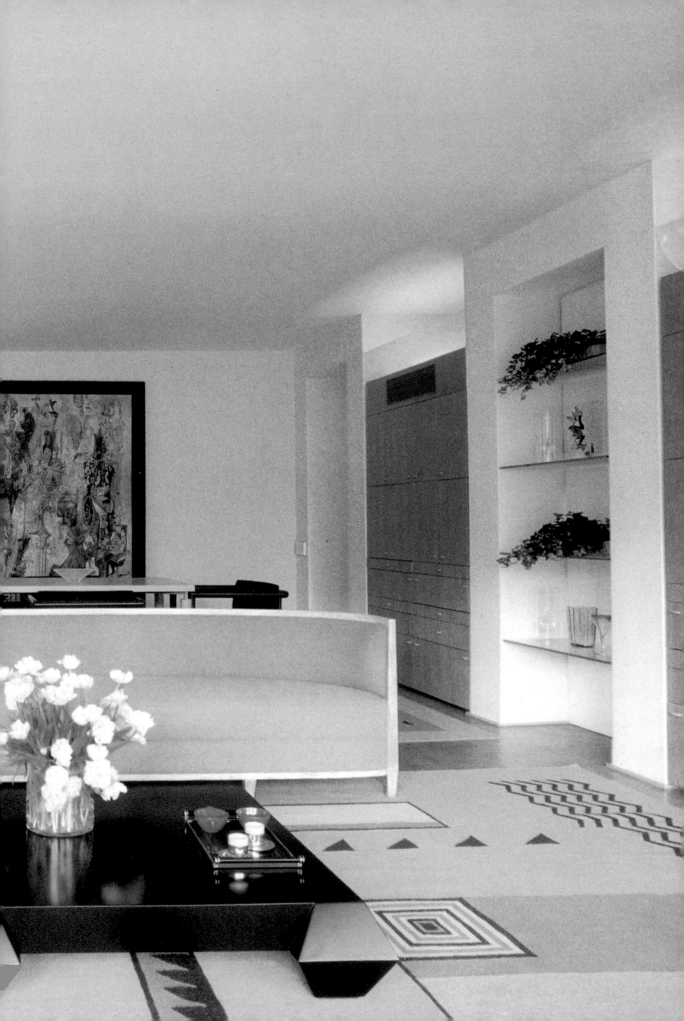

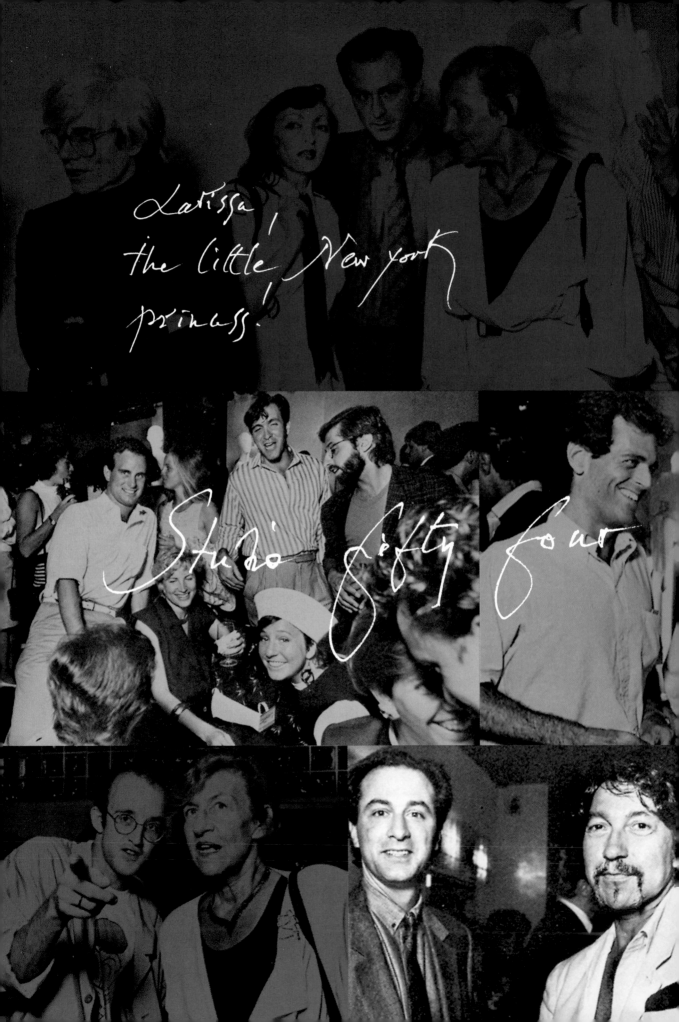

Larissa the little New York princess!

Studio fifty four

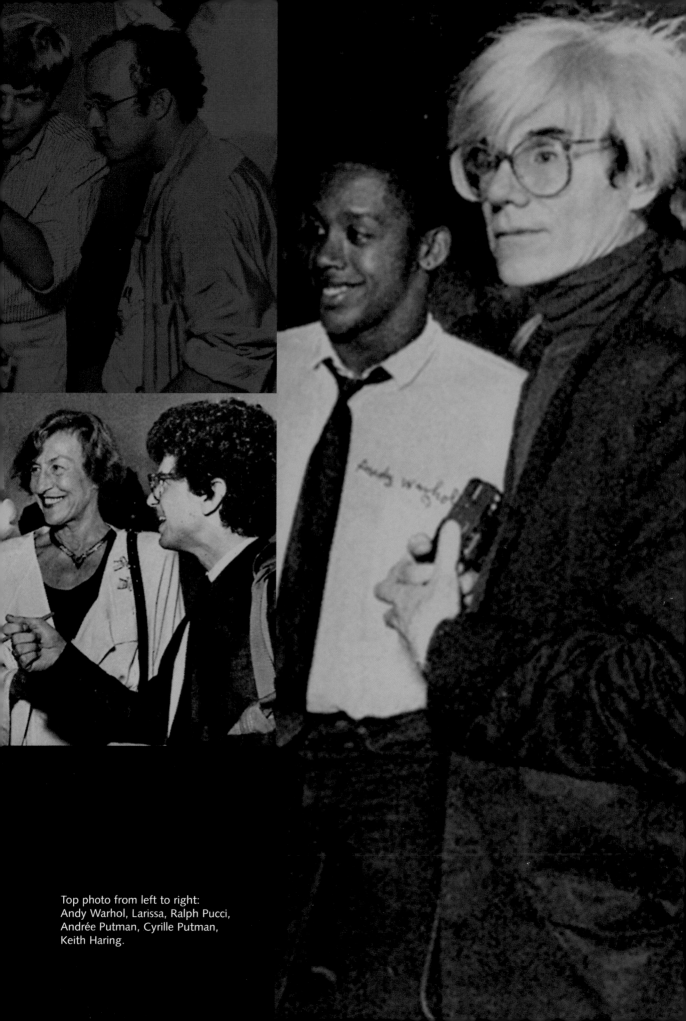

Top photo from left to right:
Andy Warhol, Larissa, Ralph Pucci,
Andrée Putman, Cyrille Putman,
Keith Haring.

Morgans
the first boutique-hotel

In 1983, Steve Rubell and Ian Schrager were what is commonly known as controversial figures. American law had forbidden them to run any establishment that sold alcohol after the resounding, fraudulent collapse of Studio 54. This time, in effort to create something resolutely different, they decided to develop a hotel. Known for her own resolute difference, they called on Andrée Putman.

After just one year of work, the result was stunning, reflecting a style so innovative and modern, it had never been seen before. Now, in retrospect, Morgans is often described as the first "boutique hotel," designed to provide contemporary travelers with accommodation resembling their contemporary style. By signing on to this project, Andrée abandoned the long-standing tradition that focused on the recollections of a luxurious past; but now she was able to share her vision of contemporary comfort, both visual and experienced.

There are some of Ecart's reissued pieces in the rooms, including chairs by Robert Mallet-Stevens, lamps by Félix Aublet and Mariano Fortuny, and also many of Andrée's own creations. Each remarkable room is featured as a sort of neutral showcase for the lives of previous occupants.

Instead of traditional reproductions of paintings, black and white photographs of flower pistils were hung on each guest room wall. For the photographer, they hired Robert Mapplethorpe, a young talent she had recently met.

As seen from the roof of a neighboring building, a suite at the Morgans Hotel. In the background, the Empire State Building. Following pages: The lobby of the Morgans.

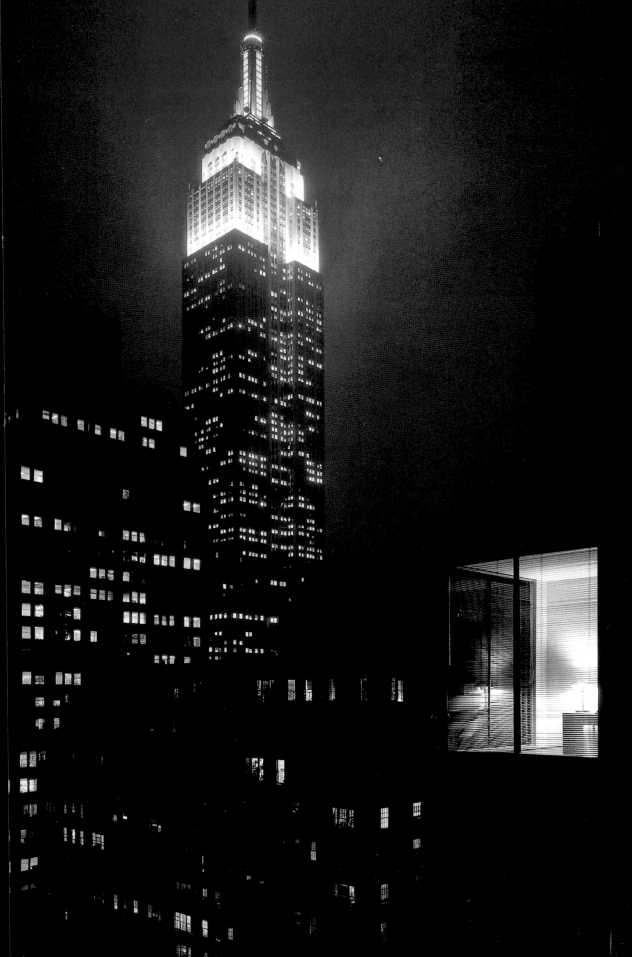

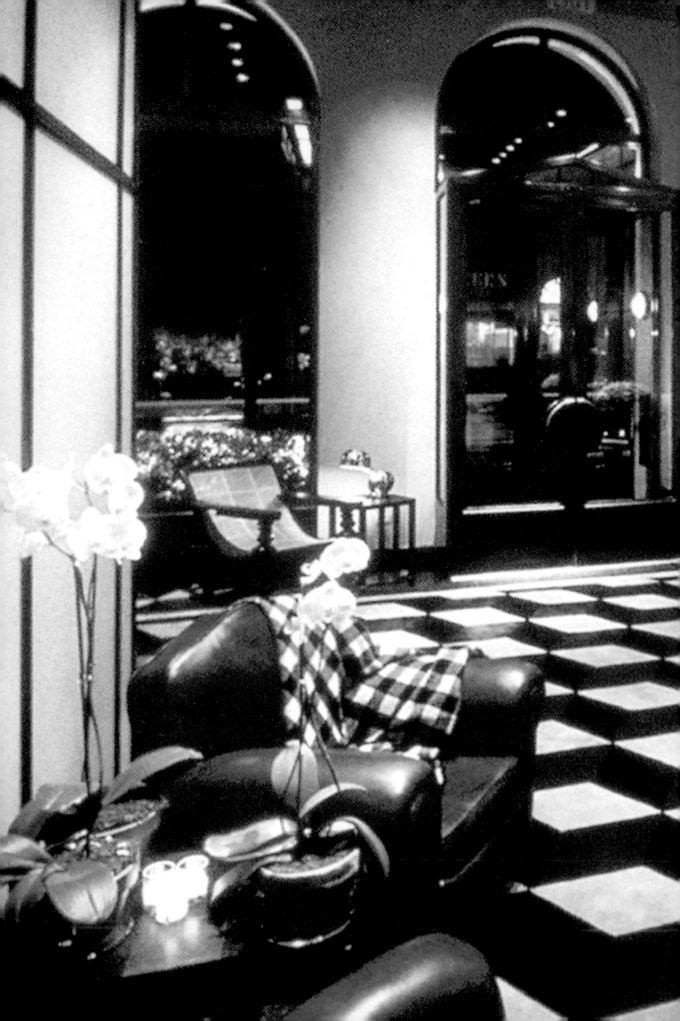

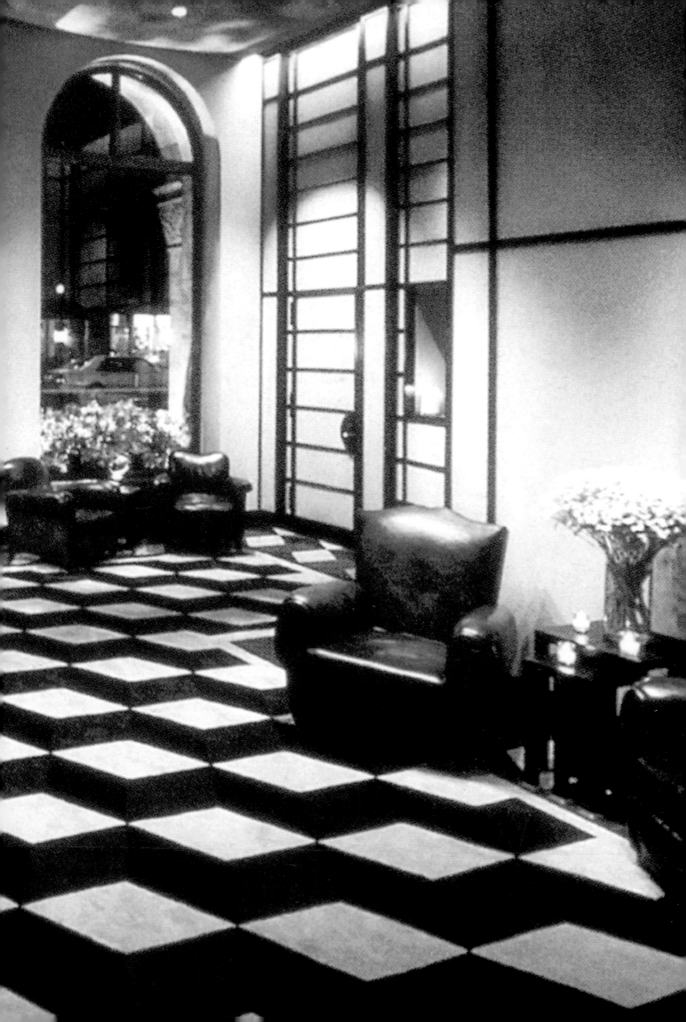

According to Andrée, the legendary black and white checkerboard ceramic tile pattern of the bathrooms is simply the fortuitous result of a tight budget. The contrast of the tiles against the specially-designed stainless steel basins, were to Andrée Putman proof that even the harmonious mixing of budget and luxury materials could be beautiful.

> "Unchanged for the past twenty years, the Morgans has become one of the top hotels in New York."

Following pages: Tiled shelves in a Morgans bathroom.
The masonry was systematically calculated so as to never cut a tile.

1-3. Interiors of the Morgans: reception desk, guest room, and bathroom.

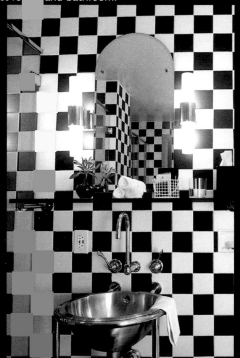

Robert Mapplethorpe.

A checkmate's triumph

66 Having to do a hotel (Morgans in New York) where I was given an almost incomprehensible budget, so ridiculous, led me to black and white. I had to use the lowest priced tile in the United States. At first they brought me little pink tiles for the bathrooms. My voice trembling with despair, I asked if they came in white...They said yes! Suddenly I realized, that's going to be horribly dull!...And in black? Yes... Ah ha! We'll do the bathrooms in black and white. A sort of potluck, with a nice metal washbasin and a few good lights... Suddenly, we had a really nice bathroom. The black and white label comes from there. **99**

The Concorde

The Concorde was born in the 1970s, the technological flagship of the Franco-British aeronautic industry. As the world's only supersonic commercial airplane, to the thrill of business people and jet-setters on the Paris-New York and London-New York travel route, the Concorde flew for almost thirty years.

In effort to modernize the interior design of its famous airplane in 1993, Air France turned to Andrée Putman. Putman the passenger, familiar with the airline from having often flown it, became Putman the informed and meticulous designer. While reorganizing the space, she was able to simplify it. She created more room by redesigning the baggage compartments. She introduced subtle indirect lighting. Inspired by a trip to Japan where the taxi seats were covered with cloths, she designed white piqué covers for the headrests. She gave the carpet a border with a black and white motif depicting an imaginary mosaic.

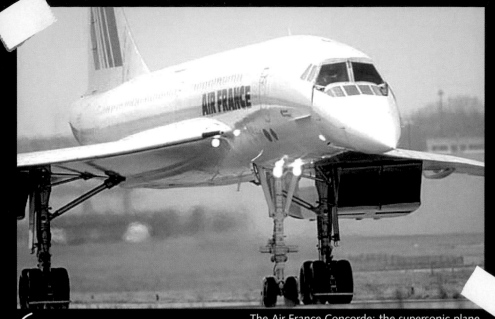

The Air France Concorde; the supersonic plane.

Supersonic

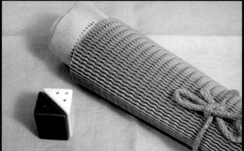

Salt and pepper shakers made of black and white enamel. In this most expensive and luxurious plane, the linen napkin is wrapped in the cheapest cardboard.

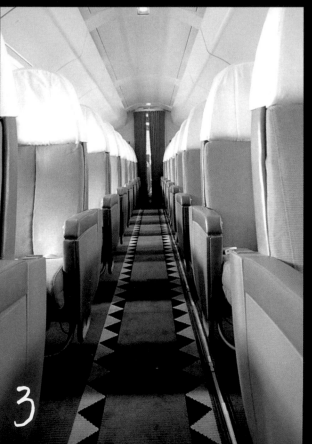

3

Interior of the Concorde redesigned by Andrée Putman. The headrests are covered in cotton piqué and the aisle runner reflects the famous black, white, and blue pattern.

1

2

66 Choosing the right materials is essential. It is the key to a success. I like to create opposition between simple things and precious details, I'm very careful with that. I also like unusual materials, such as enameled lava. 99

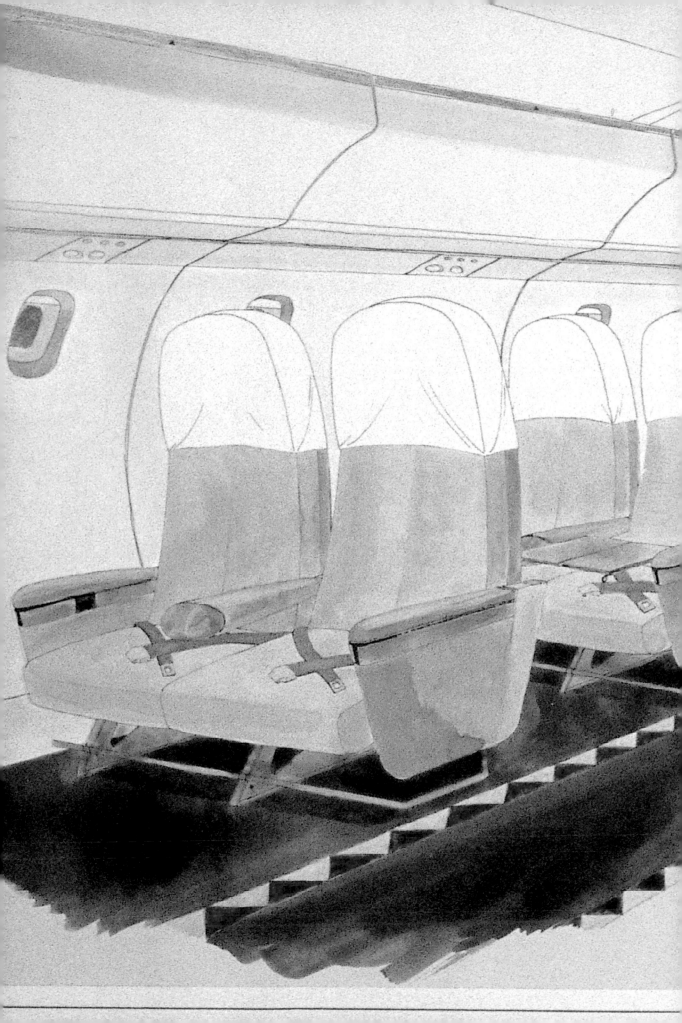

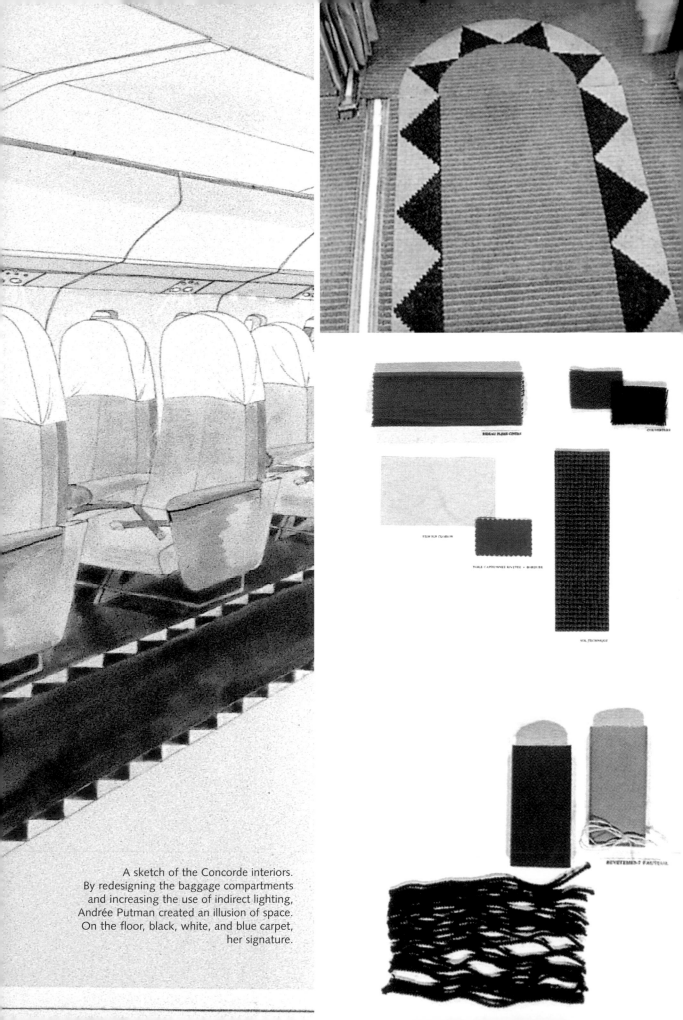

A sketch of the Concorde interiors. By redesigning the baggage compartments and increasing the use of indirect lighting, Andrée Putman created an illusion of space. On the floor, black, white, and blue carpet, her signature.

All about luxury

For Andrée Putman, the beautiful is not truly beautiful unless it is accessible to everyone, even if few choose to use it. Without such a democratic viewpoint, one may forget those left behind by this ultimate truth: wealth is unequally distributed. From the outside, her humanistic view of luxury holds foremost that it should never be forced onto others; on the contrary, it should advocate luxury's essential qualities. The farthest thing from pretentious, Andrée refuses to fall over the classic stumbling blocks of her contemporaries. She is determined to transcend the standard value systems. Farewell to the moldings and *grand siècle* interiors, farewell to the sterile reproductions of the gilded decorations of hypothetically rich and noble ancestors. "Good French Taste" was thrown aside in a radical way.

So, what then, is luxury? To define it in a society where everything changes so rapidly, and where everyone likes to give their own personal definition, is quite a difficult matter.

At the bottom of it all, Andrée sees the greatest luxury as freedom of choice: to not be forced to decide by any means, either past or present; to be oneself above all else, even in one's presented appearance, especially if it goes beyond conventional rules. This is the luxury championed by Andrée Putman. Luxury for her translates into infinite attention to detail and a strong partiality for vast spaces. Andrée has collaborated with many luxury labels, from Alaïa to Yves Saint Laurent, Baccarat, Christofle, Connoly, Ferrari,

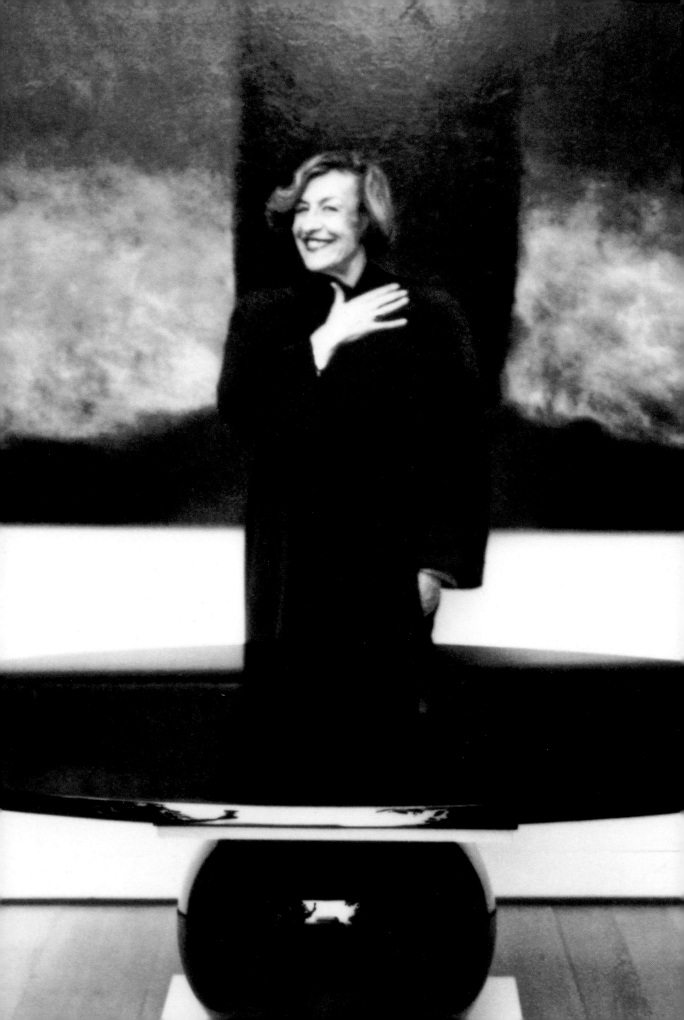

Lagerfeld, Louis Vuitton, Montblanc, and most recently Guerlain.

Of course, this has not prevented her from designing pieces for Trois Suisses, a mail-order catalog, or Prisunic, a supermarket chain. But the fundamental conflict is in the process itself: she contrasts the rich and the poor, but is conscious of not overdoing it, she reveals the beauty in simple things, and the sublimeness of luxury in just small doses.

Putman's relationship with luxury is one of the fundamental contradictions in her work—today she is a luxury brand working for other luxury brands, yet she refrains from fitting into that mold in the microcosm. As she does for her other clients, she creates a portrait of the brand by interpreting the essence of what they are. By using their genetic code, she is able to compose entirely new places for them. Between the past and the future, the timeless present is born.

Connoly boutique, London, 1995.

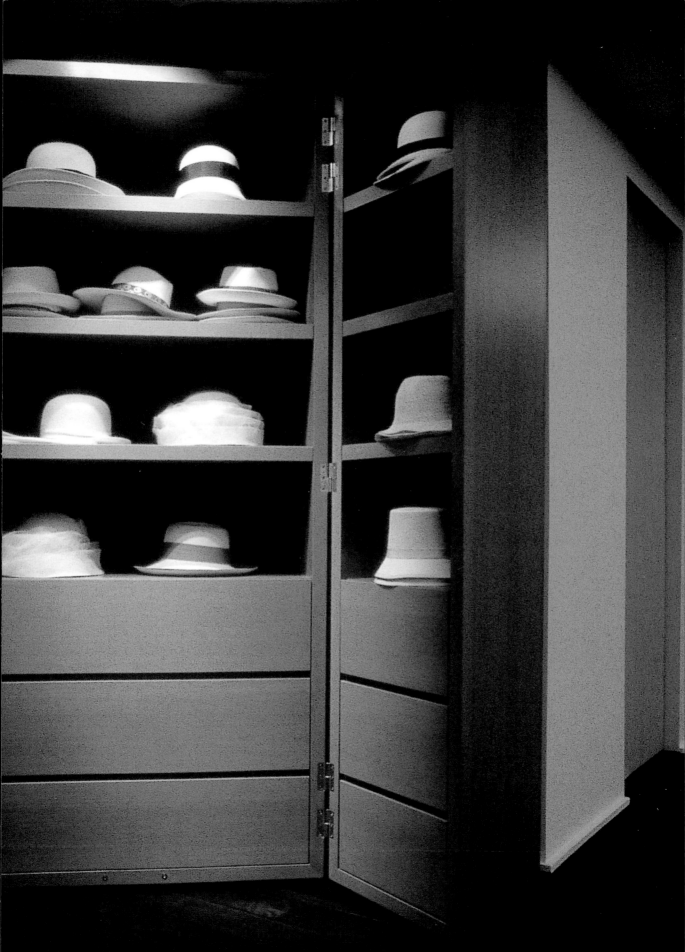

Ebel

Andrée Putman is an inseparable part of the Ebel history. This Swiss company had been making watches for other vendors for nearly a hundred years, when in 1985, the management decided to introduce a few models under its own name. With relocations to Asia already legion in the industry, and the strength of its incomparable expertise, Ebel decided to create its own brand. It saw this as a necessary step to ensure its independence—and in the long term—its survival. To consummate this transformation, it had to present a strong visual identity.

The unveiling of the new Ebel was to be at the International Watch and Jewelry Trade Show in Basel, where it had over three thousand square feet of exhibition space. After reviewing various bids, Andrée Putman's plan was chosen. She had called for an amazing set design—an extrapolation of a Swiss bank safety deposit box, the secret and precious showcase for the special jewels of watchmaker art. The diffuse indirect lighting was specifically chosen to enhance the pieces on display.

It was natural for this partnership to continue in 1987 with the restoration of Ebel's head office. Located in La Chaux de Fonds, the building by the architect Le Corbusier was called a *Turkish Villa* because of the way its art deco exterior was combined with the Oriental style characteristic of the period. More projects followed, including stores and offices in London and New York.

Reception room at the Villa Turque, La Chaux-de-Fonds, Switzerland, 1987.

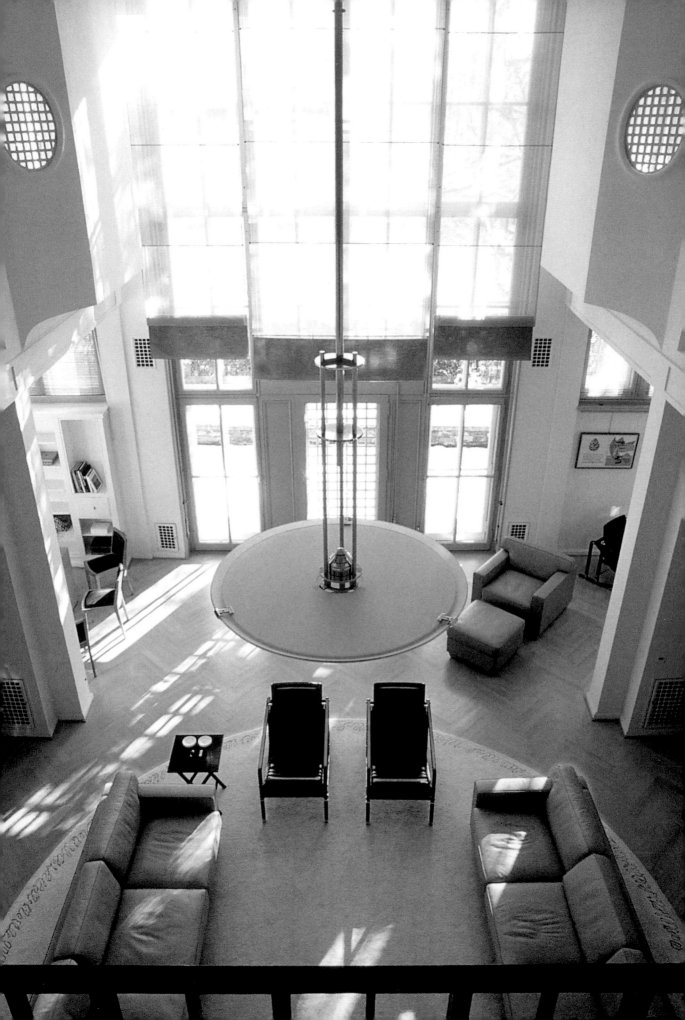

This collaboration marked the first time that Andrée Putman had developed a brand's image right from the beginning. She worked on developing the contrast between the deep-rooted image of secrecy and the ostentatiousness of the precious creations, even choosing her materials with this in mind. Sanded glass, matte gray lacquering on metallic structures, chrome chairs by René Herbst, and illuminated mosquito netting all became words in the Ebel vocabulary that would define its image.

From then on, whenever Andrée had to merge the images of both its management and clientele, she would use an analytical approach.

The Ebel Stand at the industry show, Basel, 1985.

Karl Lagerfeld

Andrée Putman and Karl Lagerfeld had known each other for quite a while before he proposed that she showcase her furniture collections in his Paris and Rome apartments. He also entrusted Andrée to redesign his offices, and his boutiques in Paris, London, New York, Melbourne, and Toronto.

Most recently, he put her in charge of the setting for the Lagerfeld Gallery—his flagship boutique on the rue de Seine. It was here that Andrée Putman developed a furniture display with a structure so complex it was equaled only by its apparent simplicity. The extremely demanding king of fashion was actually very agreeable to this apparent absence of construction, as he did not want to overshadow his own creations. His boutique had to be urbane and young, like the target clientele of the line that had since been sold to Tommy Hilfiger, but also elegant and even a bit austere. Lagerfeld's vision was to offer a fashion like the perfect "little black dress" that never goes out of style. The surroundings had to equally reflect this absolute timeless quality. Andrée created a lamp for Karl Lagerfeld, the "Tube et Béret," produced for the Préparation Meublée collection.

Following pages: "Collage-bavardage" Andrée Putman, by Karl Lagerfeld.

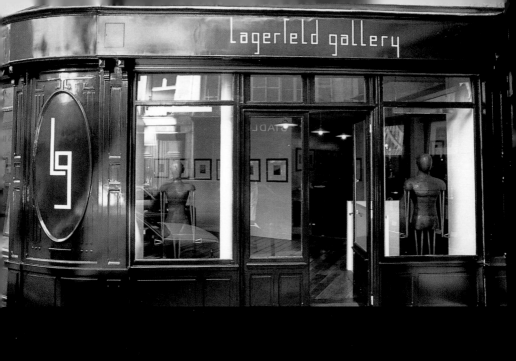

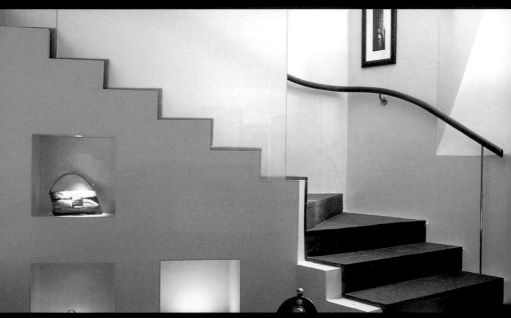

Lagerfeld Gallery, rue de Seine, Paris.

For Alaïa a wall of fitting rooms in black canvas and mirror panels

2

1

Fitting rooms made of mirrors and cloth,
Alaïa, Paris, 1985

Alaïa boutique, Paris, 1985.

3

The Carita Institute, Paris, 1988.

4

5

Connoly boutique, London, 1995.

66 Anything can be luxurious; this is almost always true as long as there is a style, a point of view. **99**

Oppsite: Balenciaga boutique, Paris, 1989.
Detail of a cabin trunk.

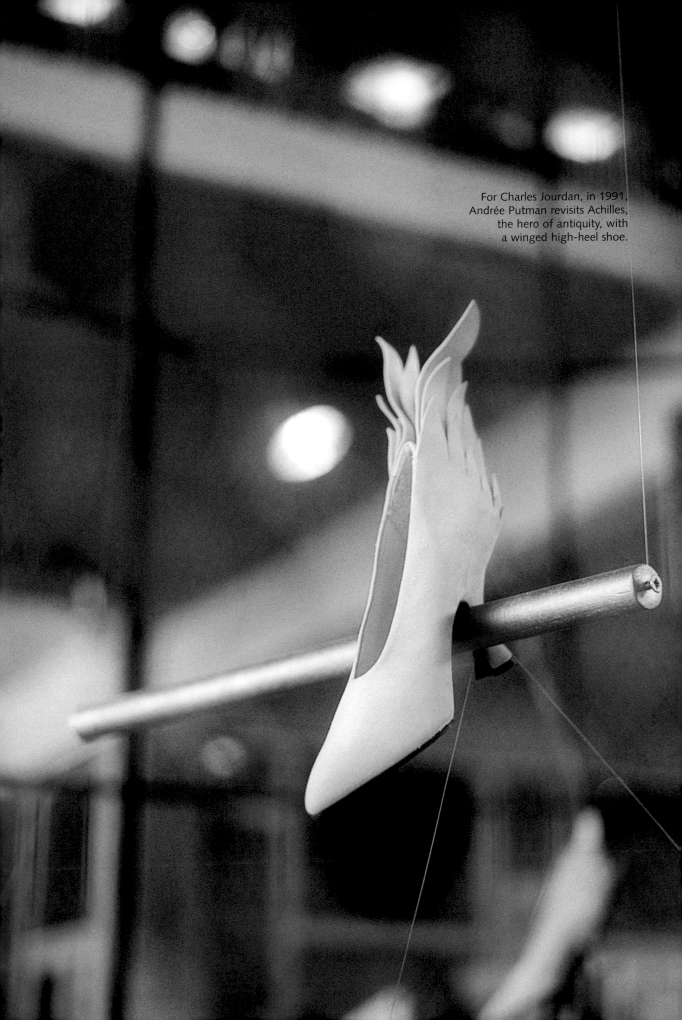

For Charles Jourdan, in 1991,
Andrée Putman revisits Achilles,
the hero of antiquity, with
a winged high-heel shoe.

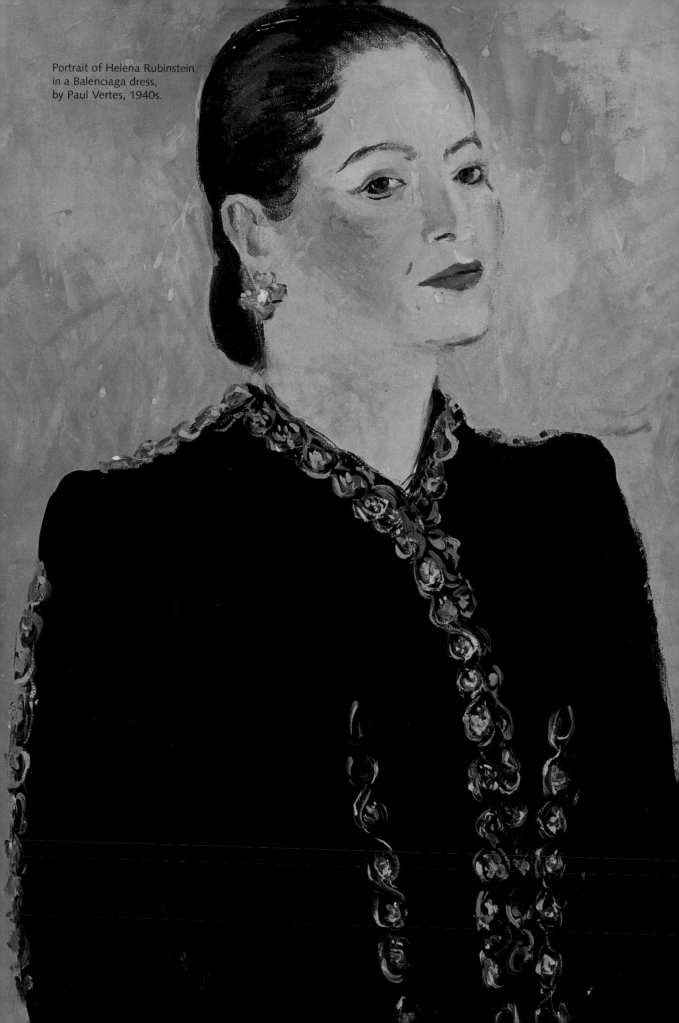

Portrait of Helena Rubinstein
in a Balenciaga dress,
by Paul Vertes, 1940s.

TESTIMONY
PATRICIA TURCK-PAQUELIER
about Helena Rubinstein

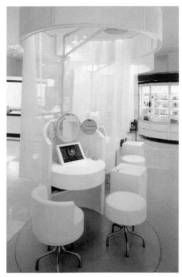

How did you meet Andrée Putman?
It was in 2001 during a breakfast in her office organized by L'Oréal. Gilles Veil had developed a program to gather together important figures from all walks of life, the idea being to talk about our trade with those who were not part of it.

What were your impressions during this meeting?
I remember being enchanted by the way Andrée recalled her first visit to a perfume superstore. Her vision struck me as being remarkably poetic. She spoke mainly of light, which is an essential element in our trade. Her knowledgable observations on the subject were astonishing.

How did you come to the idea of working together?
When I became the head of Helena Rubinstein, I knew it was imperative to develop new creative approaches. We needed a strong personality. Helena Rubinstein was one of the market leaders, but the company would still have challenges to face in the future.

Did Andrée Putman understand how to design a setting for a luxury brand?
Absolutely. My intuition told me she'd be good, and it was right. She knew how to produce spaces that were both avant-garde and glamorous at the same time. At first glance, that is a contradiction impossible to reconcile. But in fact, I feel this dichotomy is characteristic of women today, who have not abandoned the art of seduction despite their increasingly busy schedules. Andrée is like that, she is a Helena Rubinstein type of woman. Her idea of a boudoir laboratory was the exact essence in how we had been trying to express ourselves for a long time.

Did you know that she had met Helena Rubinstein?
Not at all. That was a real surprise, but at the same time it was kind of a confirmation. There are so many similarities between those two women.

Could you describe the work you asked Andrée Putman to do?
The project we assigned her could be summed up as: 'Design my home!' It was so rare to have someone so attentive to how our brand was presented. The analogy of her designing the house after a personality is undeniable. Advertising campaigns, photos, packaging, products, all make up the personality of a virtual being—the brand. This retail setting was then used in places that sell our brand around the world.

How do you view the relationship between the interior designer and the brand?
Each designer has thier own philosophy or vision of the world, which may or may not be consistent with the brand. That's why it is important to research the designer's history, while not trying to reinvent the past, but

rather by trying to rewrite its failures.
What do you think of the result?
It's my impression that the more sophisticated the details, yet the more simply that a complex brand is depicted, the more women tend to really feel valued. There is a subtle balance between the technical nature of "personal care" and the glamourous side of makeup. The surroundings now communicate this duality of our brand, without making any one aspect seem more important than the other. Andrée was able to make us futuristic, but with a warm wink to the past, creating a portrait of a living being. The use of lighting is a key element in communicating this being. The warm halo of our department store counters resembles the glowing combined aura of Helena Rubinstein and Andrée Putman.
What have you learned from this collaboration?
Once the limits have been set, a luxury brand should give a lot of freedom to the designer it has chosen. If the choice was right from the start, the inevitable ensuing harmony will enhance the brand.
How would you describe the "Putman style"?
A reconciliation between the avant-garde and humanity. It's a unique, yet familiar style that makes people happy.

My place, your place

As a teenager, Andrée Putman emptied her room of furniture. Only her bed, a chair by Mies van der Rohe and a poster remained. The courage to live in such emptiness, was that a lesson learned at Fontenay? At any rate, it was one of the founding contributions that led to her career as an interior designer. There were many spaces for herself and her family including the house at Grimaud and the loft in Saint-Germain-des-Prés. But most likely it was after taking note of her Grands-Augustins apartment that several friends, starting with Michel Guy, surrendered themselves to her input for their own domestic surroundings. Her first clients were Denise Fayolle and Maïmé Arnodin, Colette Bel, the collector Christopher von Weyhe, Karl Lagerfeld, and Jean-Paul Goude—others would follow, some well-known and some not. So what was the key to Andrée Putman's success? The answer is that she ignored the idea of trying to impose a style. She simply contemplated her client—their lifestyle, their aspirations, their values. She drew a portrait of each individual in her design of his or her space. Here was the sine qua non of successful design, the essence of the Putman style.

Like a painter, Andrée Putman offered designs that could be interpreted on several levels, or by their surprises and discoveries, their complexity masked by an apparent simplicity with a neurotic attention to detail. But these designs were created to intentionally yield to the most essential value—life.

Andrée Putman's voice is, in part, the result of smoking sixty Gitanes every day for fifty years.

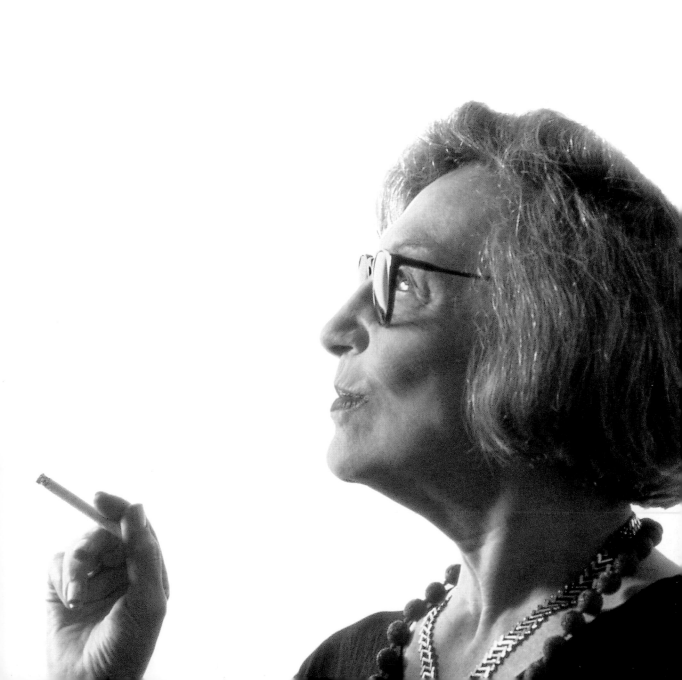

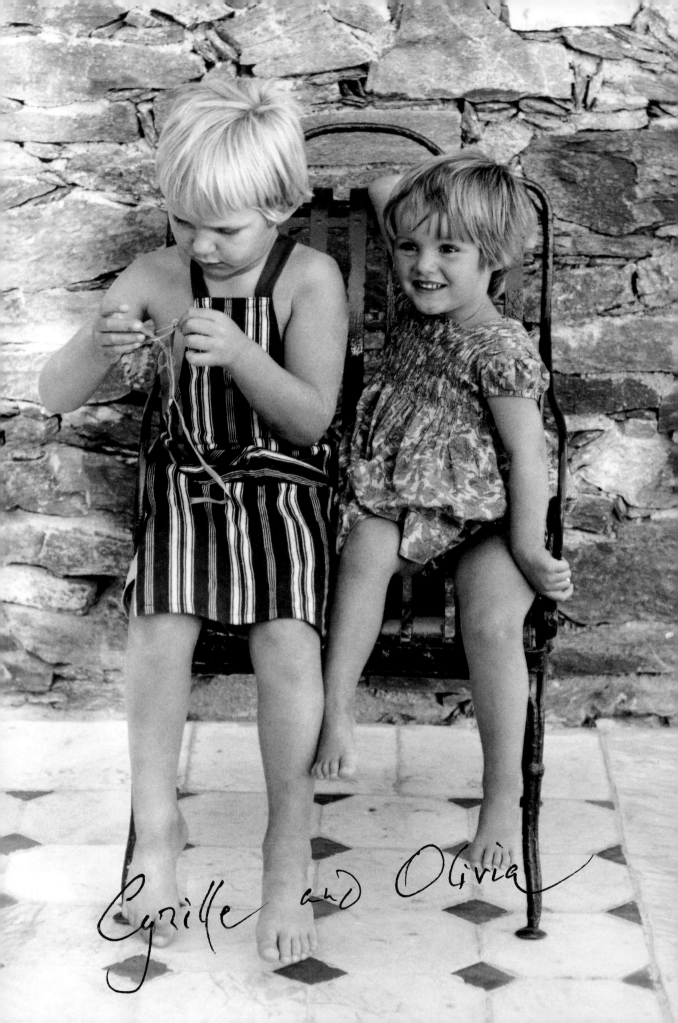

Cyrille and Olivia

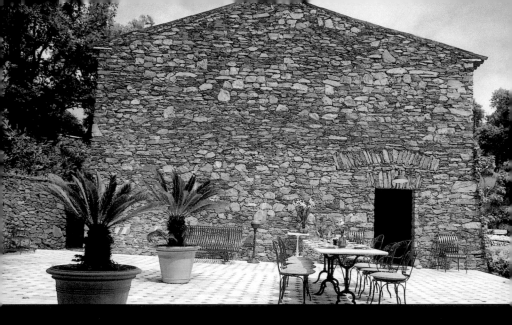

The exterior of the house, entirely designed by Andrée Putman and built from recycled materials.

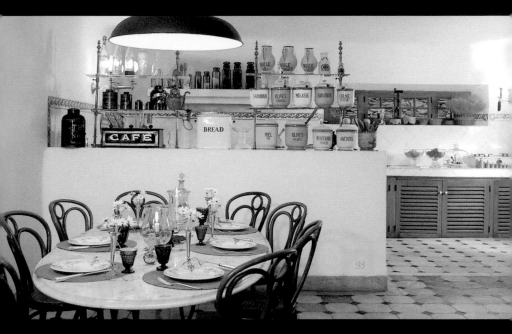

Above: The kitchen at Grimaud. Below: Butterfly bathroom,
one of Andrée Putman's lucky charms.
Opposite: Andrée's children, Cyrille and Olivia Putman, Grimaud, 1968.

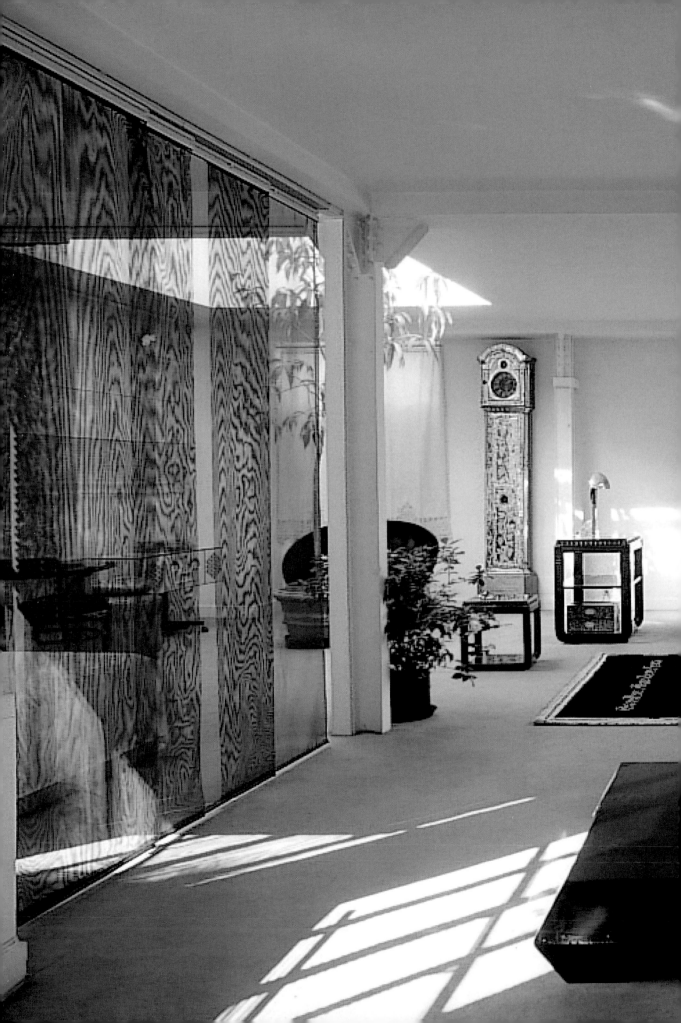

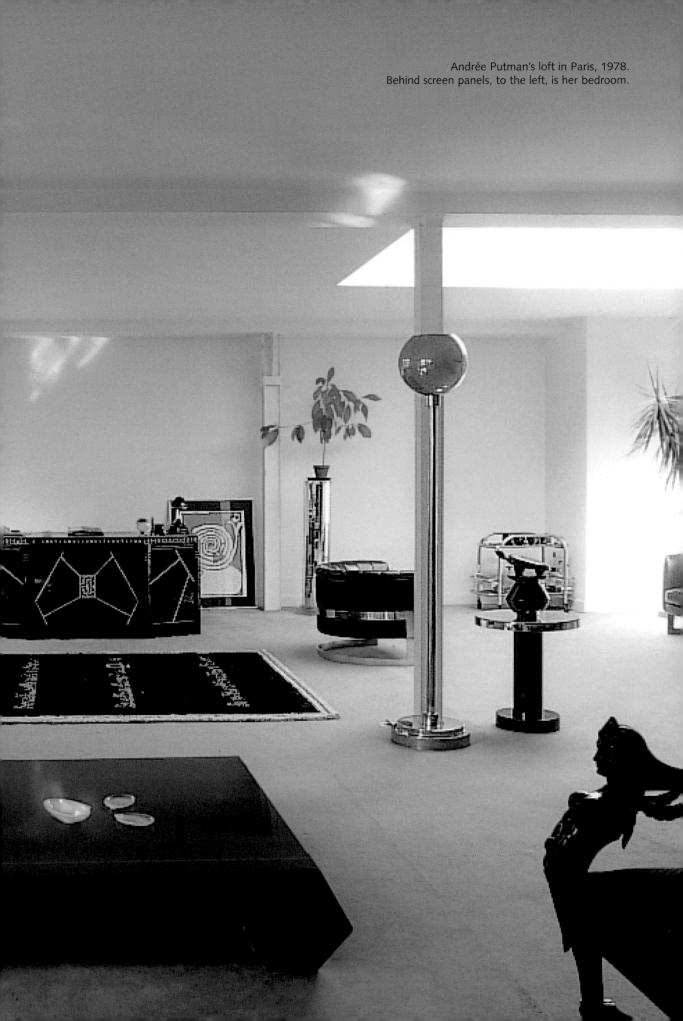

Andrée Putman's loft in Paris, 1978.
Behind screen panels, to the left, is her bedroom.

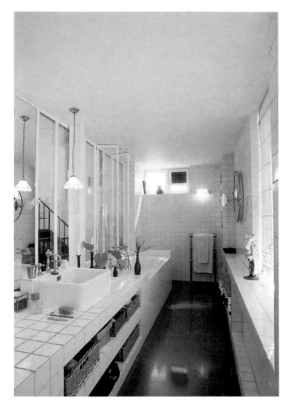

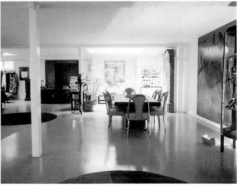

Left: Andrée Putman's bathroom, Paris 1996.
Above: A set table at Grimaud, asparagus and artichokes on "barbotine" earthenware; the Saint-Germain-des-Prés loft today.

lunch with the sun

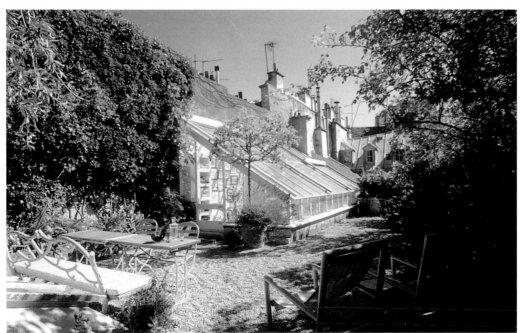

On the roof terrace of Andrée's loft, a thirty-year-old rosebush shades two chairs designed by Rob. Mallet-Stevens for the Villa Noailles in Hyères.
Opposite: The greenhouse on the rooftop terrace shelters Andrée's kitchen, where she prefers to serve her more intimate dinners. On the wall (left to right, top to bottom), the works of Jean Messagier, Robert Wilson, Bram van Velde, Marcel Duchamp, Niki de Saint-Phalle, and Jean Tinguely.

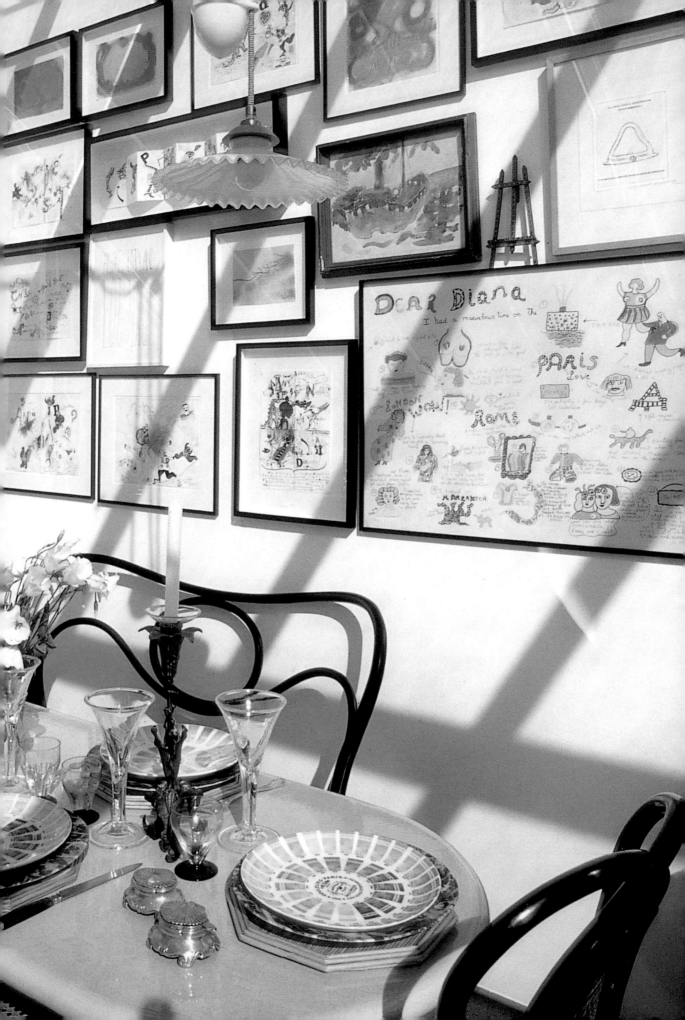

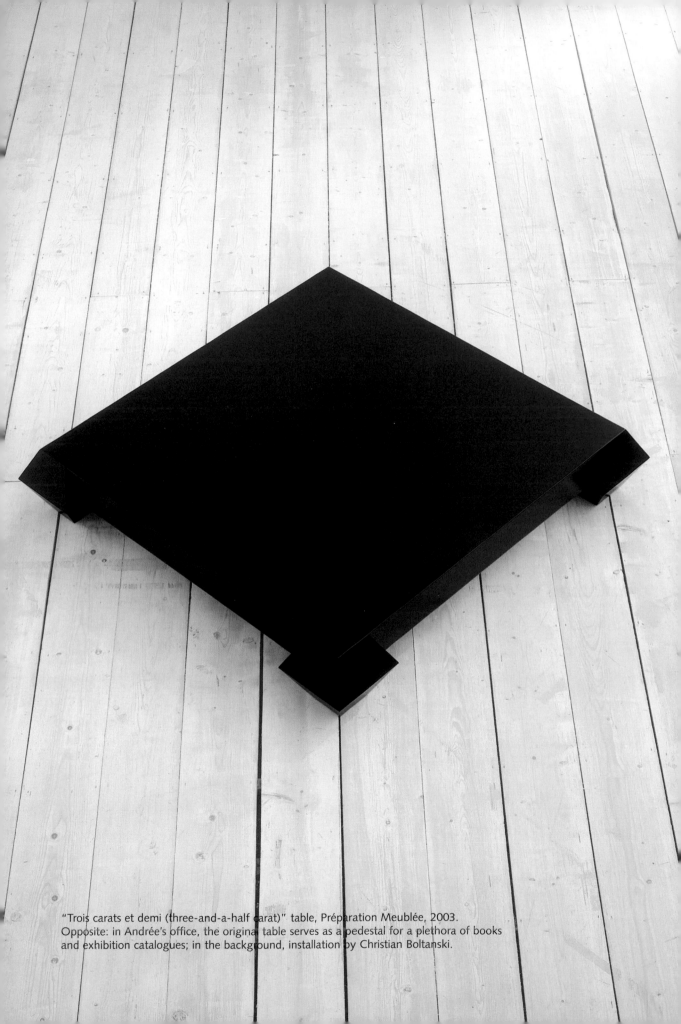

"Trois carats et demi (three-and-a-half carat)" table, Préparation Meublée, 2003.
Opposite: in Andrée's office, the original table serves as a pedestal for a plethora of books
and exhibition catalogues; in the background, installation by Christian Boltanski.

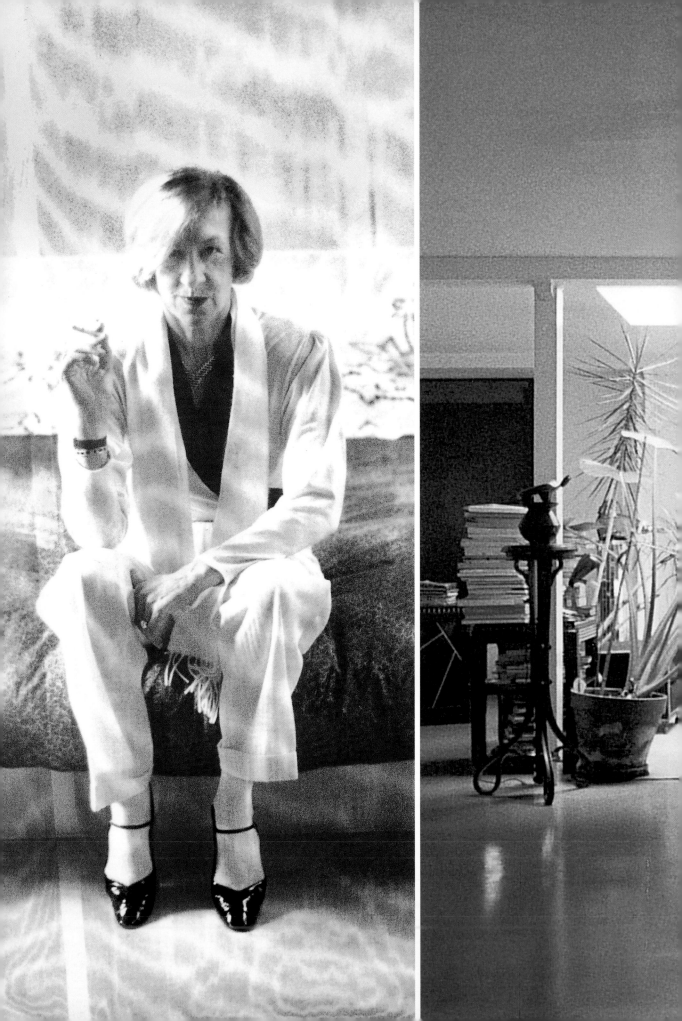

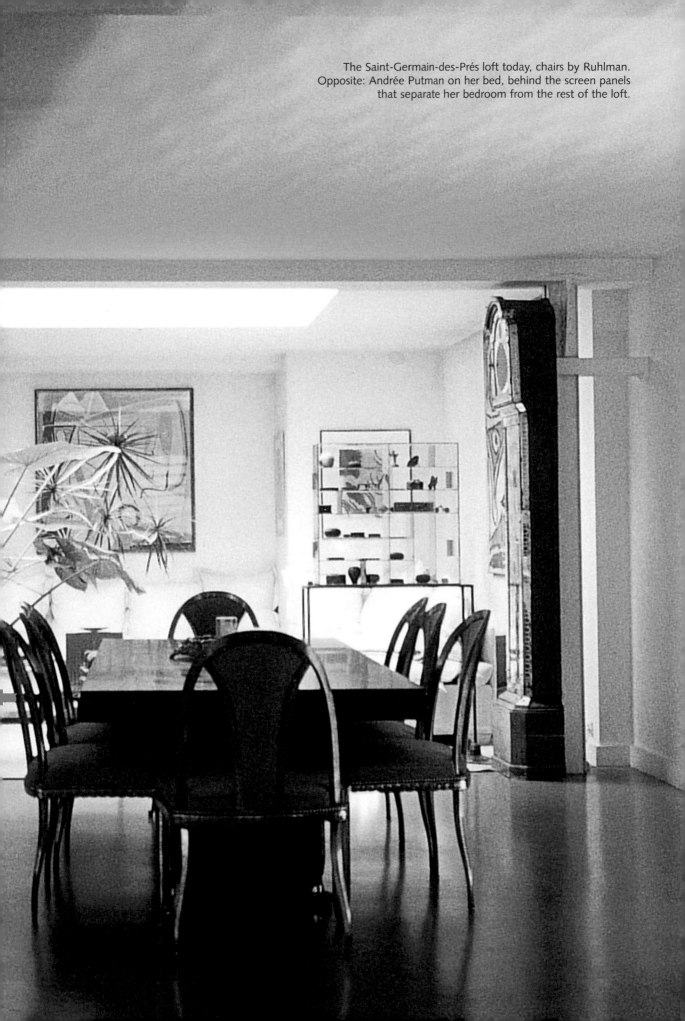

The Saint-Germain-des-Prés loft today, chairs by Ruhlman.
Opposite: Andrée Putman on her bed, behind the screen panels
that separate her bedroom from the rest of the loft.

House in Grimaud

In the beginning of the 1960s, Andrée Putman built the family home of her dreams in Grimaud on the French Riviera. Built on a rocky headland with a prominent view that extends for almost two hundred acres of scrubland, Grimaud is just a few cable lengths from the madness of Saint-Tropez. Andrée created a dried stone house, made entirely of recycled materials. The furniture was by Thonet, she slept in a Napoleonic bed and on the walls (as in life) Alechinsky rubbed elbows with Bram van Velde. Andrée was very happy there, but this happiness was short-lived as she lost the house in her divorce. Its sale was made in haste and included the furniture. The new owners have preserved the house intact to this day.

Loft on Saint-Germain-des-Près (Paris)

For many years, from the window of her bourgeois apartment, Andrée Putman could see a little metal framework factory in the heart of the sixth arrondissement that dated back to the Eiffel era. At last her modernism dreams came to life with her divorce. In 1978, she laid out the plan and the design for a magnificent loft. The woman whose ancestors had transformed an abbey into a paper mill, had transformed a print shop into a place to live.

Manor house, Paris

This woman whose creative work is the result of her close relationship with clients, this woman who paints a decorative portrait of the person when she is setting up thier new home, this "life-stylist" Andrée Putman suddenly had a hard time designing. Her newest project was to design for

Manor house, Paris, 2003.

a renovated manor home. The owner was reserved—all she knew about him was that he liked to bring back exotic foods from his many trips abroad and share them with his friends. So between an office and a storeroom, she designed a small tasting library for him. One room à la Putman! Then it hit her—the manor home would become an opportunity to extrapolate from her past creations, combining the characteristic details from her creations over the last thirty years.

She found a place for the checkerboard pattern from the Morgans Hotel (on the door of the game room on the ground floor), for the vertical garden from the Pershing Hall (surrounding the glass elevator shaft), for the Fortuny fabric from Karl Lagerfeld's sofas (the draperies in the receiving rooms), for the strips of marble from Michel Guy's "floor" in Saint-Tropez (loft on the last floor), for reflex blue, Andrée's favorite color (in the bathrooms), and for the diffuse lighting, enameled lava, wired glass, molten glass, and more of Andrée's signature details. Today, this house is considered the quintessence of the "Putman style."

House in Tangiers

Across from Spain lies Tangiers. Perched on the side of a cliff, a few hundred feet above the sea, sits the house of a well-known couple.

It was in poor condition when purchased, having long been neglected. Situated exactly where the Mediterranean meets the Atlantic, it was constantly swept by damp winds. The work would take a long time as first the structure had to be reinforced. Someone came up with the idea of filming the work's progress. Andrée suggested they ask Benoît Jacquot, for his film-making expertise. The project appealed to the

Tangiers, perspectives.

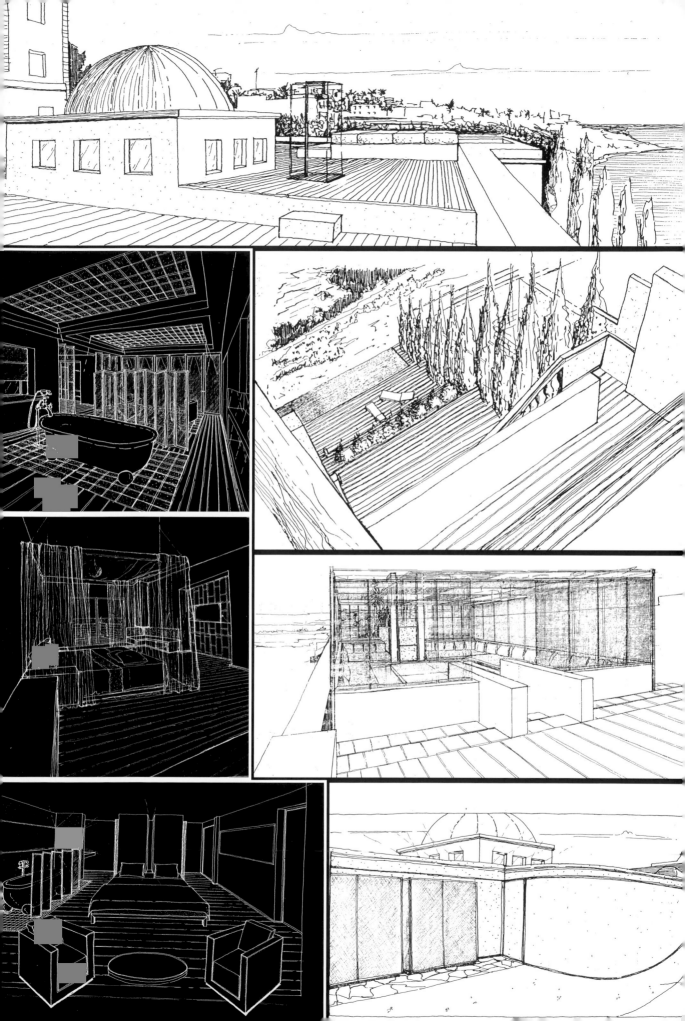

director, who was enjoying the success of his film *Marie Bonaparte* with Catherine Deneuve in the title role. He took on the documentary *Work in Progress*, achieving an almost psychoanalytical approach to a work site, the neuroses it projected, the complex relationships between the place, the designer, and the clients.

The place evolved and found its shape. All the openings were redesigned and planned so they would balance one another. From the entrance, at the highest part of the house, the view is breathtaking; a plunging trench twenty feet high opens onto the sea, which stretches to infinity. The staircase leading to the lower rooms seems to tumble into the ultramarine water below.

House, Tel Aviv

The house in Tel Aviv is inextricably bound to its owner, a businessman and enlightened patron of the arts. Of Swedish origins and though he sometimes lives in New York, he decided to set up a residence worthy of his fortune in the economic capital of Israel. His ardent passion for the area strengthened with time, but the plans for his new home were thwarted by a deteriorating political situation and his family's mixed feelings. Not having completely made up his mind, he may plan to make it a sort of academy modeled on the Villa Médicis in Rome that would house artists and help them achieve their creative projects.

House in Tel Aviv, stained-glass windows, 2004.

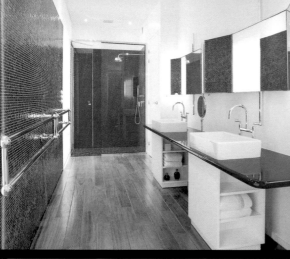

Above: Manor house, Paris, 2003: checkerboard detail in precious wood, a cupboard in the game room and a bell chandelier.

Left: A bathroom in the manor house, Paris, 2003.

Below: vertical garden installed by Patrick Blanc, manor house, Paris, 2003.

Opposite: Andrée Putman's current office in Paris, avenue Denfert-Rochereau.

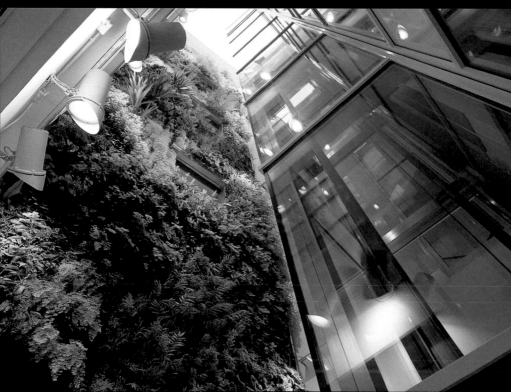

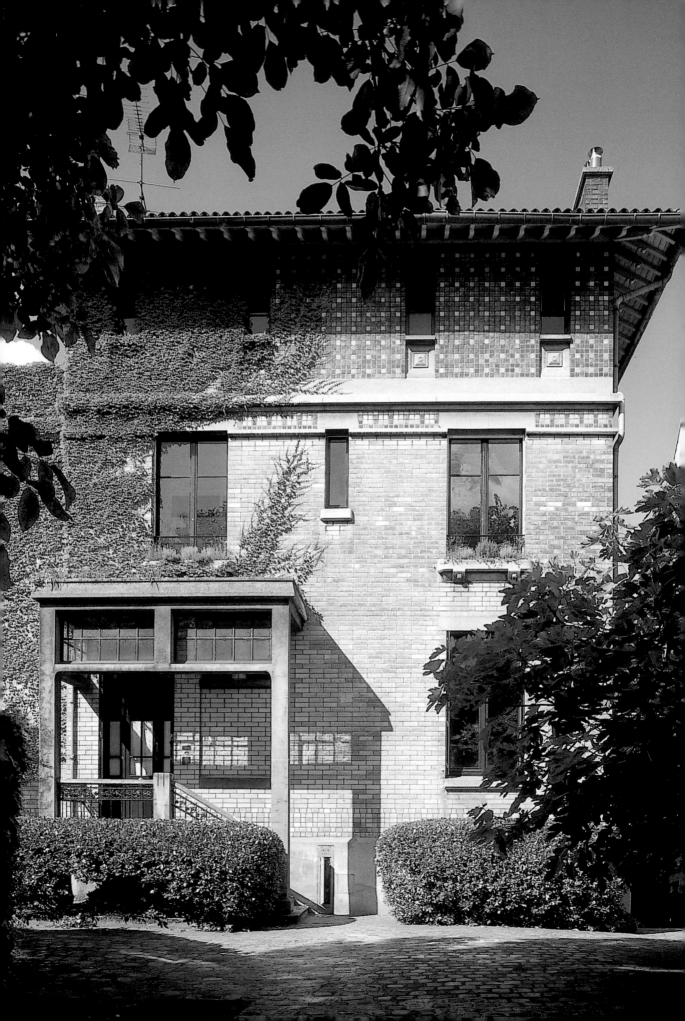

Gildo Pastor Center, Monaco, 1996: stairs and desk.
Opposite: Andrée Putman had promised a staircase like a necklace of light.

I had promised a staircase like a necklace

Set for the pillow book
Peter Greenaway

Set for the Peter Greenaway film,
Pillow Book, 1995.

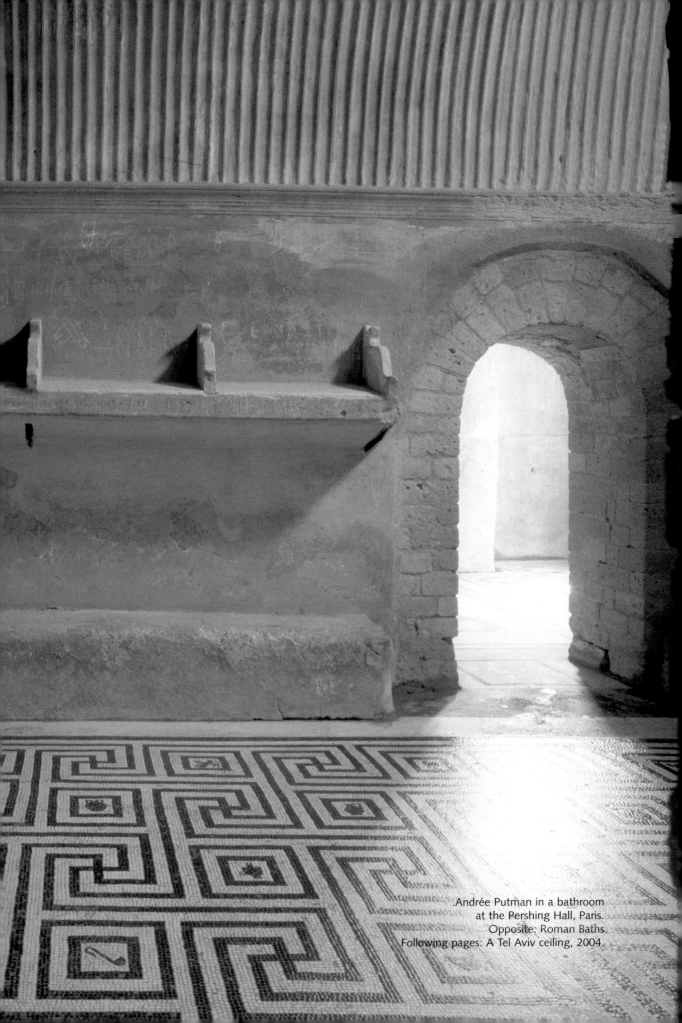

.Andrée Putman in a bathroom
at the Pershing Hall, Paris.
Opposite: Roman Baths
Following pages: A Tel Aviv ceiling, 2004.

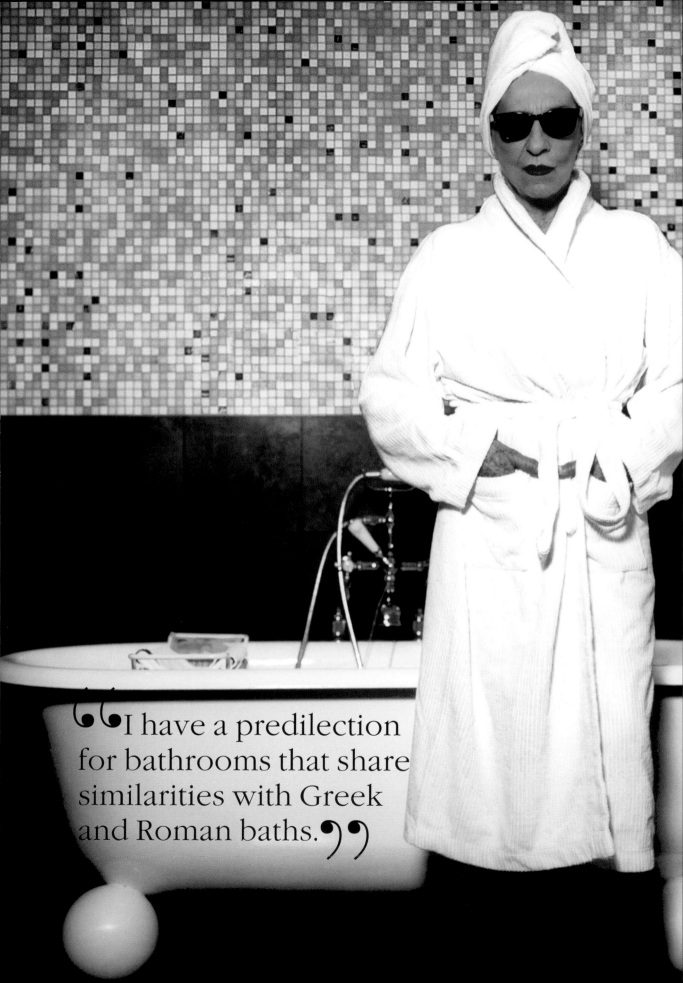

I have a predilection for bathrooms that share similarities with Greek and Roman baths.

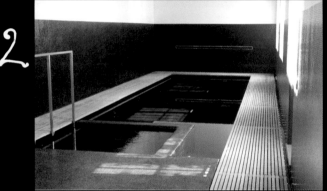

The master bedroom.

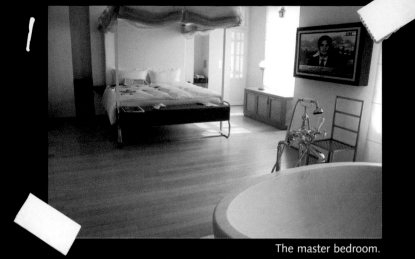

Kitchen and dining room.

The indoor pool covered in deep blue molten glass, bordered in teak.

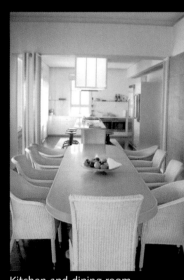

A modern palace

In front of a stained glass window she designed,
Andrée walks up the staircase, November 2004.

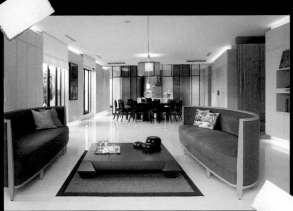

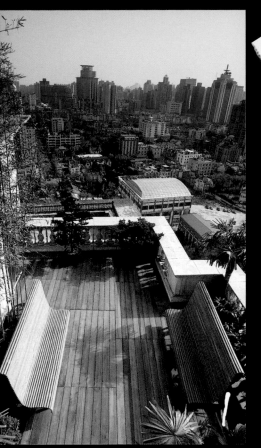

2 The loft, the showpiece of the apartment. A unique space measuring more than 1,000 square feet combining the living room, dining room, and at the far end, the kitchen.

Plunging view from the loft's terrace. Background, low colonial houses in Shanghai's old French Concession district side-by-side with Pudong's skyscrapers.

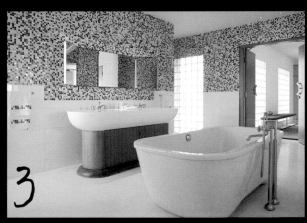

3 The bathroom. Bathtub designed for Hoesch, adjacent to washbasins inspired by those originally devised for the Carita Institute. On the walls, tiles inspired by the Morgans checkerboard, 2004.

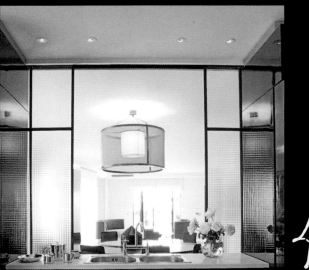

4 Separated from the rest of the loft by sliding, pull-out partitions of safety glass, the kitchen allows the owners to cook while talking to friends or to host meals for sixteen.

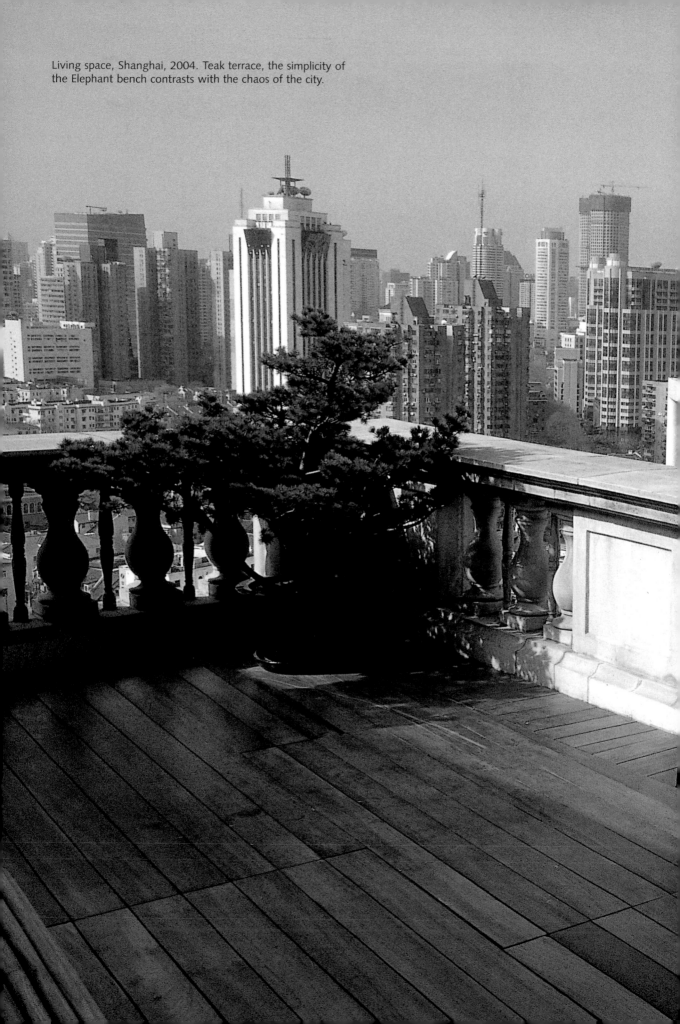

Living space, Shanghai, 2004. Teak terrace, the simplicity of the Elephant bench contrasts with the chaos of the city.

TESTIMONY
ARIELLE DOMBASLE
The Andrée touch

Andrée, like certain mystical Italian figures of the Quattrocento, is foremost an alchemist of life.

Wise but enigmatic, she can transform herself. With an extremely rare talent, she seems a woman looking for nothing, but who knows how to find everything.

Any project with Andrée is a delight because she keeps her promises like true beauty that holds a promise of happiness. Her every word is true, her every action seems to come from within. For Andrée simplicity is born only after long preparation, but seems to flow from her as naturally as a garden following nature. Andrée arranges the world by expert orchestration, unhesitatingly putting the "essence" of things back in control. She presents a configuration of strength that comes only from within. It all comes down to removing the superfluous in order to restore the beauty of shapes to their original simplicity. Andrée is a builder of cathedrals and her gods are the gods of style. This style that has the added grace of always traveling incognito with a look so natural and yet so very much there—this is the Andrée touch.

But Andrée is also a friend, a friend who is exquisitely alive—she is one-of-a-kind, attentive, tactful, affectionate, and forever watching over you. Her sensitivity, her words chosen so precisely and intellectually, her ethics worthy of a Carmelite, her charm, her nobility, all combined with the curiosity of a child. With that deep, irresistible voice punctuated by wild laughter like a perpetual joker playing his tricks, she reminds us, always the impertinent one, to find the irony in things. In a word, Andrée is a rare and beautiful human being, and someone I will love and admire forever.

as, "foreigners like my work because they think it is very Parisian, but in France I have long been considered an eccentric."

Even if this assertion has found exception with time, it is true that throughout her career the majority of her work has been in other countries: the Hotel Im Wasserturm in Cologne, the Wolfsburg Ritz-Carlton in

Hotel Le Lac, Japan, 1988.

Germany, or the Bastide restaurant in Los Angeles. The Sheraton, the pointed building in the middle of Terminal 2 in the Roissy Charles de Gaulle airport, was awarded the prize for the best hotel, a prize voted on awarded by...foreign business people.

Several elements go into the making of a successful hotel. According to Andrée Putman, the first is abandoning the hokey idea to make it a "home away from home." Andrée believes it better to create a building with a true personality, that is fun to go back to precisely *because* it is nothing like the house you live in during the rest of the year. As each city leaves its own impression on a visitor, each hotel should also offer a unique experience. Furthermore, Andrée requires service far beyond the norm from any of the hotels associated with her name. Her first experience with Ian Schrager left an impression on her. Service should be thoughtful and unassuming, but show personality.

Hotel Pershing Hall, Paris, 2002.

Above all, one should never act like the stuffy servant of a pompous aristocrat! And as far as the towels in the bathrooms go, you can never have too many! It's always good to plan the lighting, such as the sunshine in the morning...there are so many details that are every bit as important to the interior design as the materials chosen and their magical arrangement.

1

Ritz-Carlton, Wolfsburg, 2000.

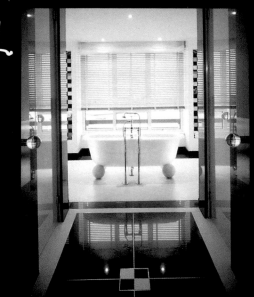

2

Ritz-Carlton, Wolfsburg, 2000.

3

Hotel Im Wasserturm, Cologne, 1990.
Opposite: Bar at the Wasserturm Hotel.

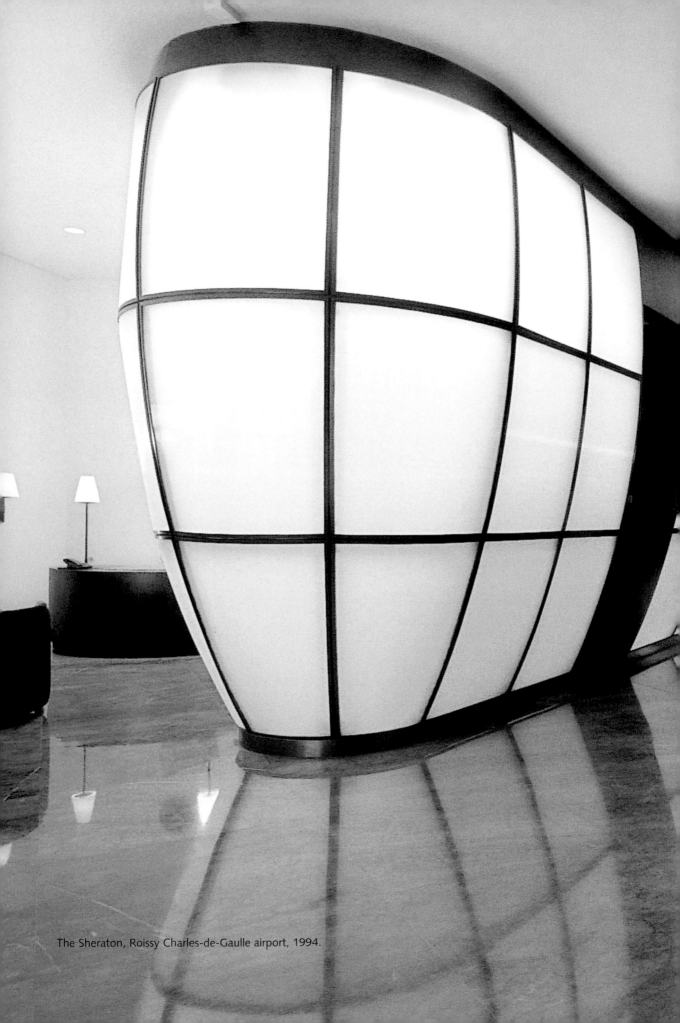

The Sheraton, Roissy Charles-de-Gaulle airport, 1994.

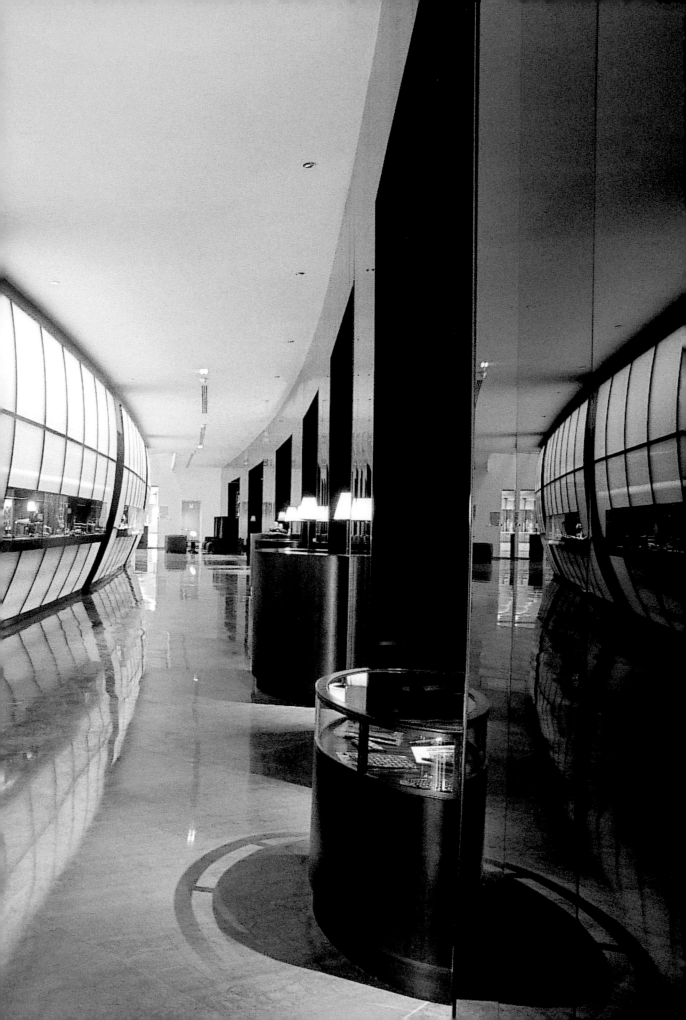

Lô Sushi I & II

In 1999, when the entrepreneur Laurent Taïeb decided to bring the Japanese concept of sushi on a conveyor belt to France, he called on Andrée Putman who he trusted to capture the feel of the Orient without overdoing it. Instead of copying the Zen style that was quickly taking over the French interior design industry, they had to go beyond the conventional attitude of the neighborhood situated in the eighth arrondissement of Paris, a veritable bourgeois center. The plan was to use a very modern setting for the conveyor belt and open kitchen that were centrally arranged in the space. When all was said and done, Andrée Putman had designed one of the most timeless places of her career. Its unassuming style against the technical nature of the concept is still highly regarded today.

The second part of a similar adventure began in 2002, with the purchase and restoration of Samaritaine by LVMH. Her project in the basement was particularly difficult as it was an unattractive, almost disturbing, space with no light and low ceilings. Her first concern was to divert focus from the absence of windows by adopting a large wave of blue light. Its ink-spot design was taken from the papers used for bookbinding in the nineteenth century.

Lô Sushi, Paris, 1998.

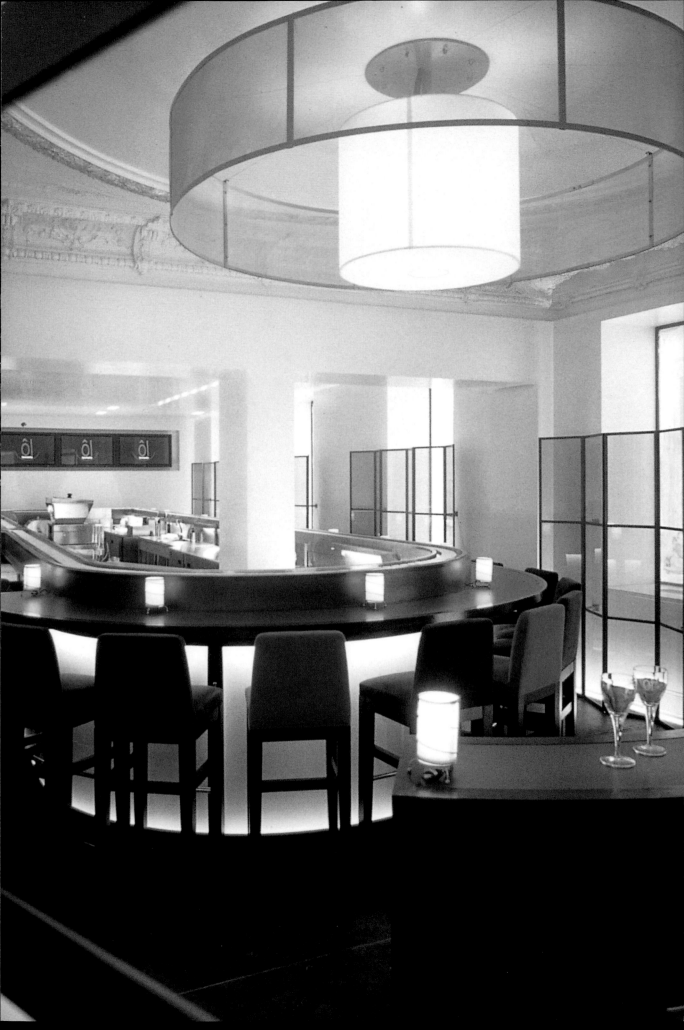

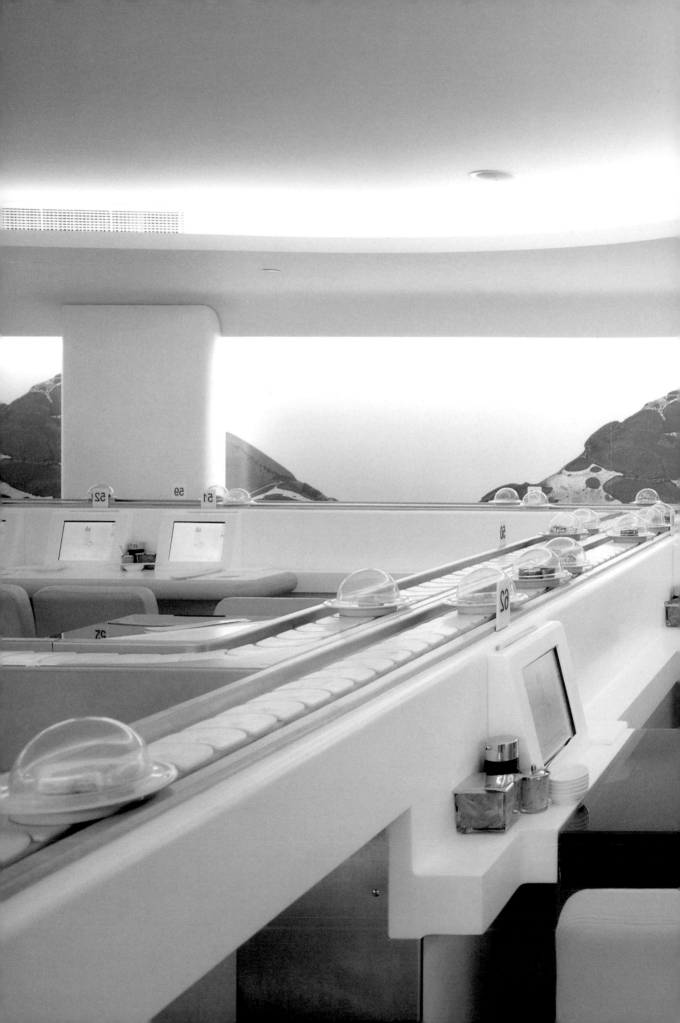

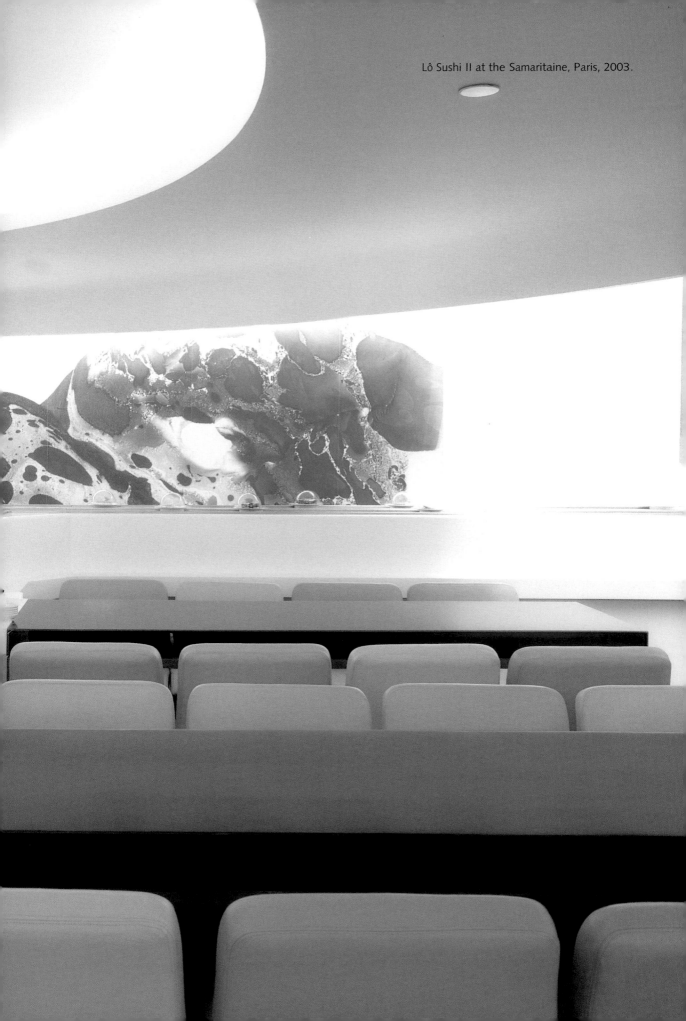

Lô Sushi II at the Samaritaine, Paris, 2003.

her Polka tea service for Gien and the Vertigo silver hollow-ware for Christofle? Visually, none. However, they draw on two of Andrée's memories: a samovar noticed during an official trip to Soviet Russia, and a dented thermos bottle. These mementos inspired by Andrée Putman's life and combined together in her visual memory, reveal the complexity and depth of her spirit. They are also part of a playful, mischievous approach, its

Ferrari Exhibition, Cartier Foundation for contemporary art, Jouy-en-Josas, 1987.

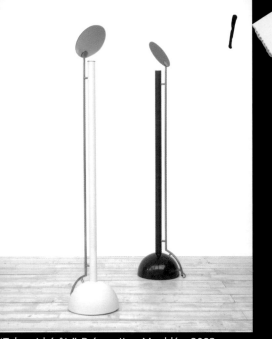

"Tube et bérêt," Préparation Meublée, 2003,
original created for Karl Lagerfeld.

Elephant bench, Préparation Meublée, 2003,
original created for the CAPC in Bordeaux.

Préparation Meublée

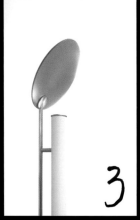

"Tube et béret," (detail).

"Table Rond sur Carré," Préparation Meublée, 2003,
original created for Les 3 Suisses.

"Luxury products are becoming commonplace because of subsequent reproductions. We have seen trademarks crumble, then die of mediocrity, licensed products handicap the brand by their lack of credibility."

Clothes rack for Les 3 Suisses, 1997-1999.

impossible not to detect the humor inherent in her process. Despite their seeming dissimilarity, none of the objects surrounding her is there by chance. Individually they may reveal their uniqueness, but their full implication is only apparent when incorporated as a whole.

For a house to be successful, the objects in it must communicate with one another, respond to and balance one another, and reflect the personality of the designer who put them there. The objects created by Andrée Putman naturally fill these criteria, but it is difficult, even impossible, to find in them a systematically expressed identity, but that is not the point.

The period crowned by Créateurs et Industriels, where her impeccable taste found the most extraordinary objects with assured ease, is not over. Eclecticism, empowered by choice remains. Andrée Putman cannot be defined by one sole genre.

Her first "pure" creations were probably the furniture designed to supplement Ecart's reeditions. Brilliantly neutral, they stand out because they enhance what's around them. Andrée Putman developed her interior design skills through the selection of her reeditions: a lamp by Mariano Fortuny, another by Félix Aublet, a sofa by Jean-Michel Frank, a chair by Robert Mallet-Stevens, and a carpet by Eileen Gray, and it was not unusual for all these objects to live side by side. Her pure creations, therefore, had to maintain a certain neutrality, but still be able to stand alone, if necessary.

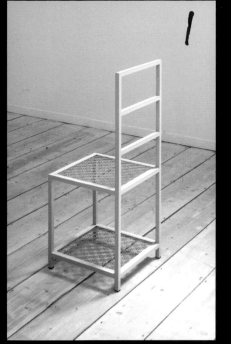

1

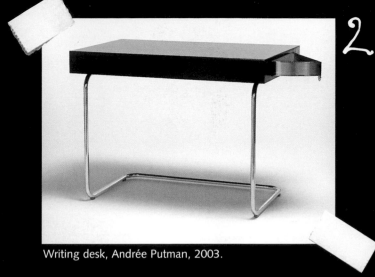

2

Writing desk, Andrée Putman, 2003.

"Sèche-Linge" chair, Préparation Meublée, 2003.

3

Glasses, Andrée Putman by l'Amy, 2000.

4

"Compas dans l'œil" lamp,
Andrée Putman by Baldinger, 1996.

5

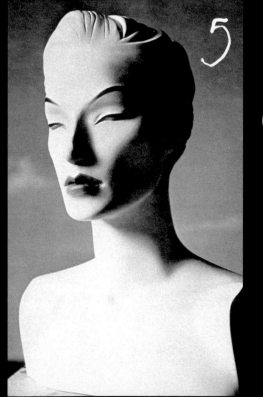

"Marotte," Andrée Putman for Pucci, 1986.

"Consumption is no longer capable of responding to our predecessor's expectations of becoming more human. The planet is exploding and installing a two-tier system; they consume objects as signs, but the enthusiasm has disappeared."

The Christofle
Vertigo Collection
the magic ring

The Vertigo collection from Christofle marked the beginning of a long collaboration between Andrée Putman and a silversmith who was looking for new contemporary design. To renew its line and especially its clientele, Christofle turned to the woman who had become known as the "high priestess" of design.

Her creations began with a ring. As was always the case with Andrée Putman, the story started with memories, first, she learned those of Christofle, then created connections with her own. In her mind, since childhood, like so many other objects she was inspired by, this time the throughout her life, the hot chocolate thermos she used during autumn walks in the Gardens of Luxembourg was designated. It lived in her creative mind until she had converted it into an entire line for the silversmith. The Vertigo line today numbers forty pieces for the table. In 2005, she has begun working on jewelry made from sterling silver. Andrée's grand finale promises a tension necklace, also a sublimely magic combination of memory and creative process.

Andrée Putman for Christofle: Vertigo ice bucket (2000).

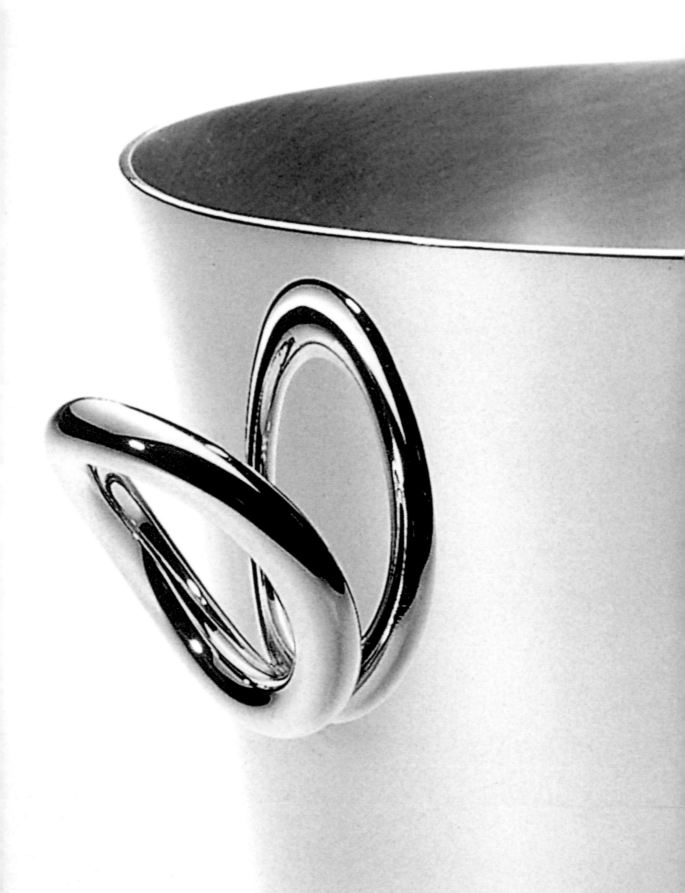

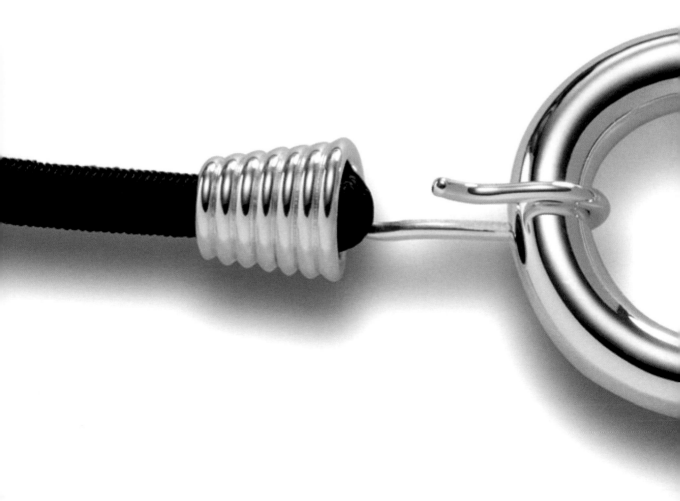

Vertigo tension necklace and ring, collection "925" (2005).

Les Préparations

In 2000, Andrée Putman decided to make one of her dreams come true; she would create her own perfume. The smell of her mother's perfumes, L'Heure Bleue and Shalimar, was all too present in her memory. The meeting with the beautiful Olivia Giacobetti, one of the better "noses" of our time, finalized it. To describe the scent she envisioned, Andrée shared her memories of a trip to Asia, a river-crossing in a junk, the fragrance of water and drift wood. At the same time, Putman was working with the researcher Patrick Blanc on his first vertical garden for the Pershing Hall Hotel. While there as well, she rediscovered the tropical mugginess that reminded her of that river voyage so many years ago. It took Andrée more than a year, but she finally found her scent. At the beginning, the idea was to produce no more than five hundred bottles of Préparation Parfumée (as she decided to call it), for her friends. But their insistence and the success of a commercial trial at Colette (the legendary fashion concept store in Paris) caused her to use the scent in a variety of products and market them. In 2003, Andrée Putman's collaborators convinced her that she needed to reissue some of her own creations—perfectly ironic considering she was the woman who started her career with reeditions of other designers' furniture. She introduced a careful selection of representative furniture: Crescent Moon, a sofa created for a New York apartment and since used in several layouts, including Jack Lang's office at the National Education Ministry, and the low table 3 Carats et Demi naturally became part of the line called Préparation Meublée.

Préparation Parfumée, Andrée Putman, 2001.

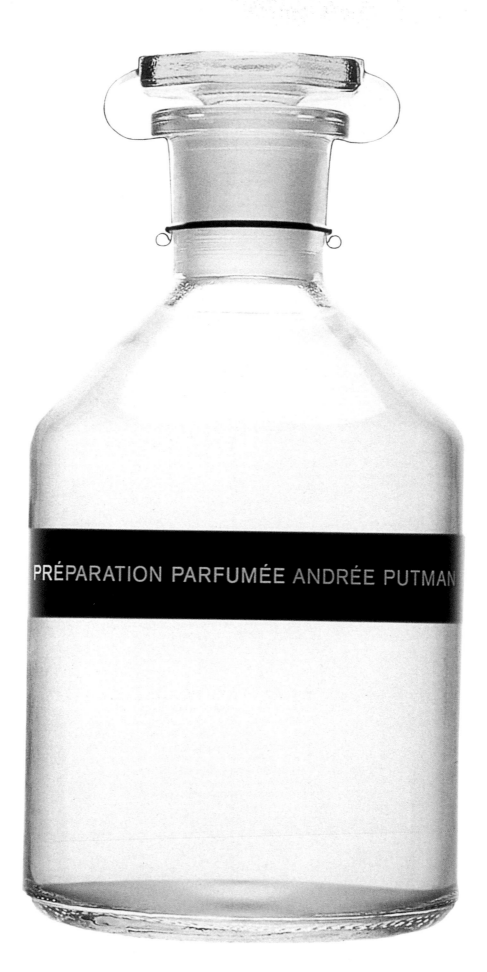

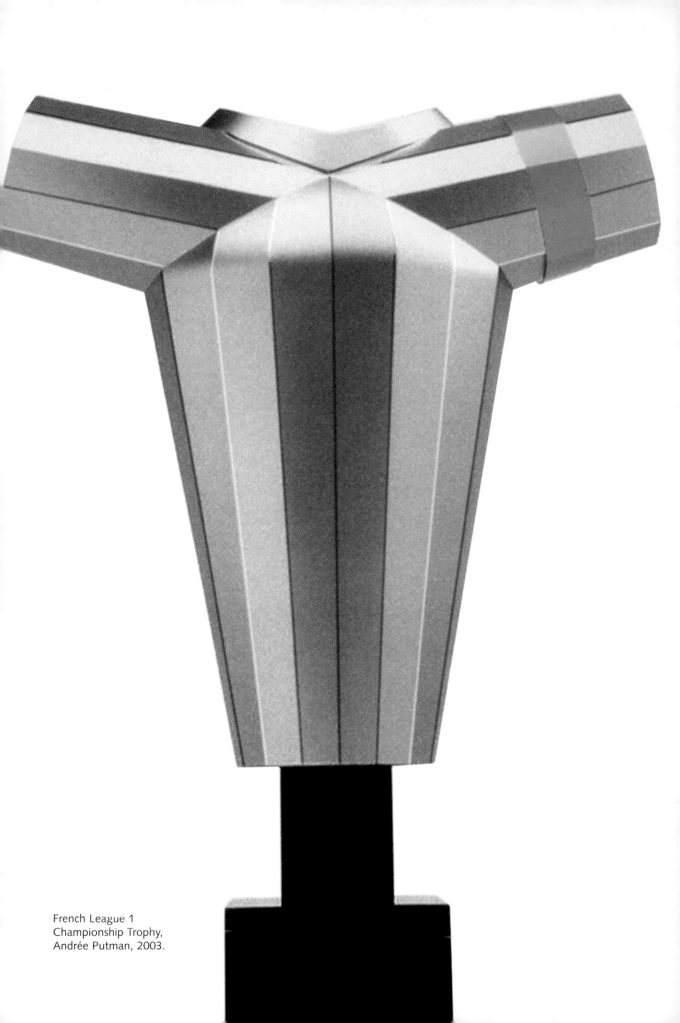

French League 1
Championship Trophy,
Andrée Putman, 2003.

Trophy for
the French Soccer Championship League 1

In 2002, it was decided that the French soccer championship should have a truly original trophy. The task of choosing a designer was assigned to a panel of independent experts, made up of men and women from all walks of life: the arts, entertainment, academia, and media. Word has it was Bernard Pivot and the gallery owner Enrico Navarra who were the first to suggest Andrée.

She welcomed this new challenge with amusement. The importance of the winning jersey was taken very seriously. But what other symbol would show the effort and also transcend differences? So it was Andrée's idea that each year it would be adorned with the winning club's armband.

6 6 Athletes and us—the ones called 'designers'— are very close. We share this obvious fact: "We free ourselves by surpassing ourselves." It was a liberating gesture to replace the form of the traditional cup with a jersey. This second skin for players conjures up the swelling of the lungs, the exertion of the heart, and the line of the shoulders that heralds the V of victory. 9 9

The Allure

It is impossible to write about Andrée Putman without discussing her specific allure. Jack Lang defines her as "a living national treasure." Didier Grumbach thinks her looks are part of what she's selling. Judicaël Lavrador started an amusing interview with the words "her erect, fluid silhouette," and the insolent Philippe Tretiak calls her "unsteady, flickering, a puff of air."

I remember an anecdote recounted for me by a friend: one stormy night at a dinner in Venice, some guests disembarked from a speedboat onto the rocky beach. Only one remained standing, unperturbed, during the crossing. The boat had barely docked when Andrée twirled around without a grasp on the handrail, she seemed to float above the storm, standing perfectly upright as usual. An admiring friend asked Andrée what was the lucky charm she was holding in her hand? "Oh, just a broken heel."

Andrée Putman is highly identifiable, she is a woman who never travels the world unnoticed. Her waved hair, her height, her upright bearing, her clothes, her spike-heeled scuffs, her gravelly voice, all leave an impression on those who meet her. Undeniably, Andrée Putman's work has touched several generations and will touch several more. But history will also remember her dignified manner, her ghostly silhouette, her presence, her aura.

Portrait of Andrée Putman by Pierre & Gilles.

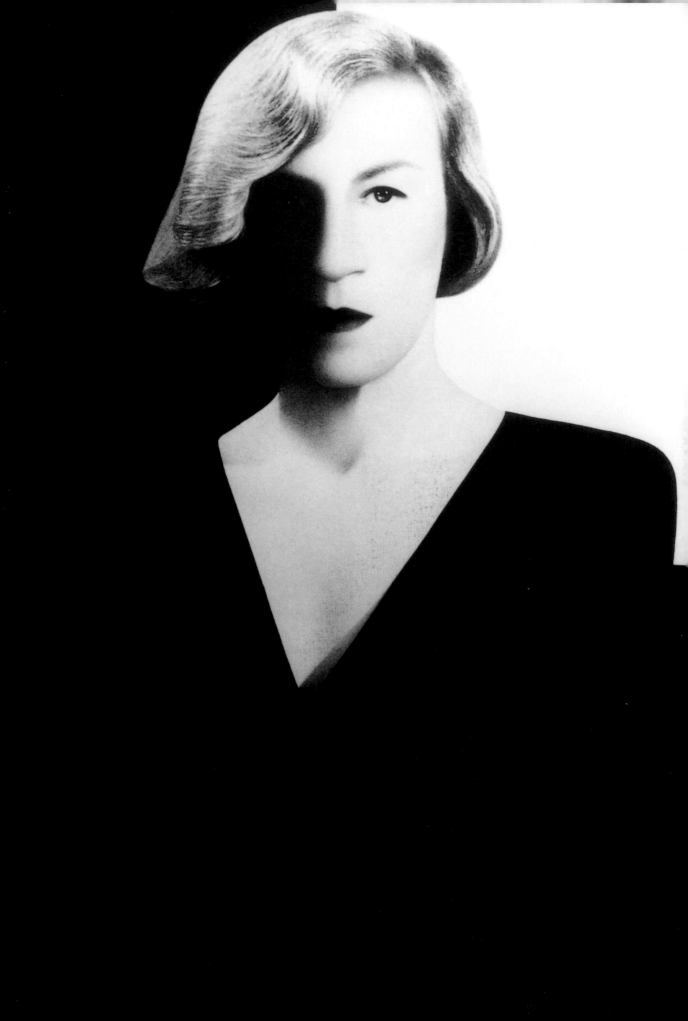

Andrée Putman surrounded by Bruno Sinanian and
Nicolas Petraut, co-presidents of Bruni, with whom
she created a collection of cashmere mini-scarves.

66 It has never been done better. 99

The most dangerous seductor

Cary Grant.

66 One of the things
that fascinates me, is the
number of blacks that exist.
I like to wear blacks that
clash and that are clearly
different! Accessories
that are green-black,
warm-black, brown-black,
blue-black. It's very,
very beautiful, all these
false blacks together! 99

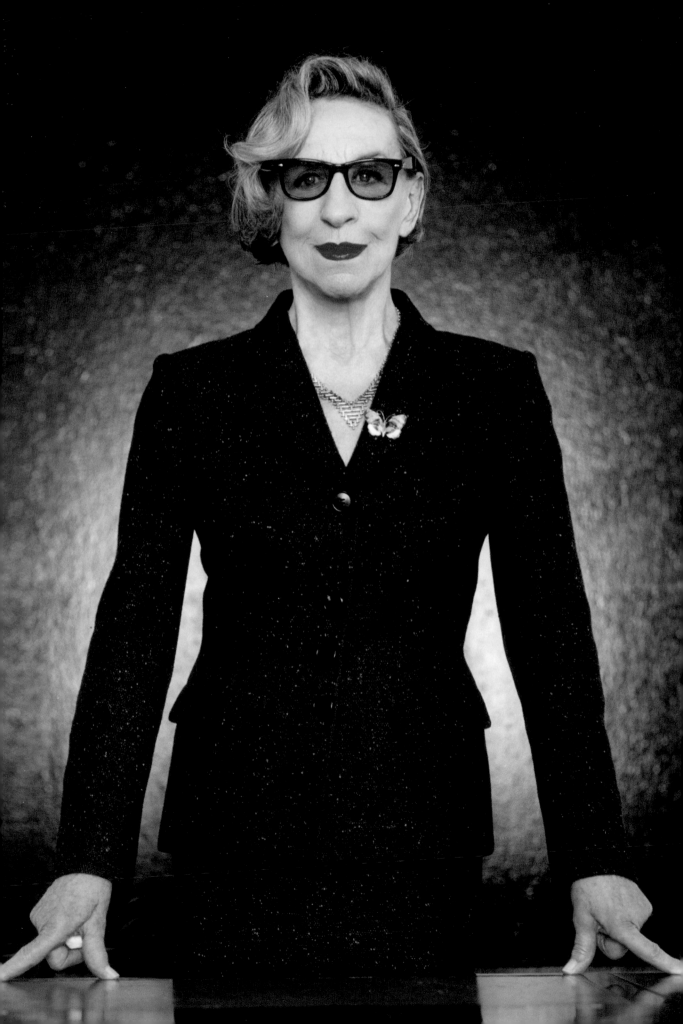

TESTIMONY
BENOÎT JACQUOT
Stubborn Discipline

You have had the privilege of observing Andrée Putman. What is the importance of her personal style in her work?
Among those who create, whatever their background, you will notice that their gestures express their temperament, their relationship to the outside world, and therefore their personal style. The difference is in whether or not they are aware of their style. It is a difference of perception, but the bond is an intrinsic part of the artist. A person's style is the extension of his organic and living self, through his gestures.

How does Andrée Putman's look make you feel?

When I was young, often people would be classed as distinguished or not. I thought this was an old-fashioned notion until I met Andrée whom I had been introduced to by Michel Guy. I didn't know who she was, nor what she did, but I was immediately struck by her classic look of distinction. Andrée Putman was distinguished in the true meaning of the term—you noticed her. She is distinguished.

Do you think this distinction has influenced her work?
Her work also has this distinction. On several occasions, I actually recognized her work. I have often noticed a place, and stopped and admired it, and then later found out she was the one who created it. I have almost always found "Andrée's things" without knowing they were hers. They are distinguished. This distinction influences all her work—she distinguishes objects and isolates them if necessary, so they can find their place.

How is Andrée on the screen?
To paraphrase André Breton, she is "immobile explosive". Even immobile and without expression, she explodes and produces modern beauty.

For several months, you have been filming Andrée Putman on a building site, and you have been following the progress of the work with her. What has been your approach?
It was built around Andrée's movements. The film follows her pace, giving rhythm to the movement between spaces and to the gradual transformation of a house into a work of art. I tried to film the relationship between the style and the process.

What did you learn about her work?
I was surprised to see how profoundly artistic her gestures were. I found a process, an approach very similar to that I had observed among artists in other fields. With one small difference—Andrée dreams for others. She dreams on command, and with accounts to be rendered. This concrete translation of her work into a tangible, real result is an added constraint that is only possible with real discipline.

For you, what is the "Putman style"?
The accuracy of the dream.

Opposite: Andrée Putman in Azzedine Alaïa.

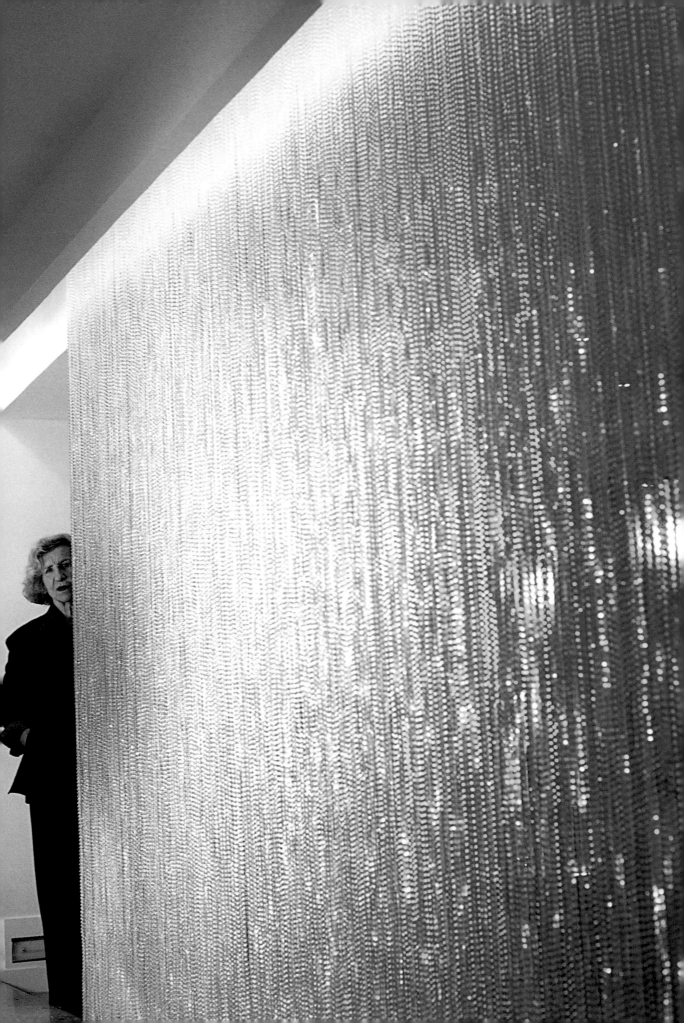

Main Projects

MUSEUMS

CAPC, Bordeaux	1990
Beaux Arts, Rouen	1992
Private museum, Dallas	2003

HOTELS

Morgans, New York	1984
St. James Club, Paris	1987
Le Lac, Tokyo	1989
Im Wasserturm, Cologne	1991
Sheraton, CDG airport, Paris	1995
Ritz Carlton, Wolfsburg	2000
Pershing Hall, Paris	2001

EXHIBITIONS

Ferrari at the Cartier Foundation, Jouy en Josas	1987
Les Années VIA, Paris	1990
60 years of Haute Couture, Ohio	1990
Guggenheim Museum, New York	1999
Christmas windows at BHV, Paris	1998
Hans Bellmer, New York	2001
Personal exhibitions in China	2004

MOVIE SET

The Pillow Book, Peter Greenaway	1995

SUPERSONIC AIRPLANE

Concorde	1994

RETAIL SPACES

Thierry Mugler, Paris	1978
Yves Saint Laurent, USA	1980-1984
Hémisphere, Paris	1981
Alaïa, Paris	1985
Carita, Paris	1988
Ebel, New York	1989
Balenciaga, Spain	1989
Georges Rech, London	1991
Et Vous, Paris	1994
Bally, Genève	1994
Lagerfeld Gallery, Paris	1998
Connolly, London	2000
Helena Rubinstein, around the world	2004-2006
Guerlain, Paris	2005

RESTAURANTS

Le Bon Marché, Paris	1988
Le Lac, Tokyo	1989
CAPC, Bordeaux	1990
Orchid Club House, Kobe	1992
Total, Paris	1994
Le Bureau, Monaco	1996
Lô Sushi, Paris	2000
Patisserie Pierre Hermé, Tokyo	2001
Pershing Hall, Paris	2001
Bastide, Los Angeles	2003
Lô Sushi II, Paris	2003

OFFICES

Ministry of Culture, Paris	1984
Ebel, Headquarters, Villa Turque, La Chaux de Fonds, Suisse	1985
Ministry of Finances, Paris	1987
Regional house of Aquitaine, Bordeaux	1987
Commission for human rights, Arche de la Défense, Paris	1989
Arte TV headquarters, Paris	1992
Regional House of Bouches du Rhône, Marseille	1994
Marie Claire, Paris	1995
Studio Chanel, Paris	1995
Gildo Pastor Center, Monaco	1996
French Federation of Haute Couture, Paris	2000
Ministry of Education, Paris	2002
Natexis Private Bank, Paris	2003

PRIVATE RESIDENCES

Numerous residential projects and interiors around the world

Photo Credits

Acknowledgments

The author would like to thank especially Andrée Putman and Martine Assouline.

He also thanks, for their direct or indirect participation, their availability, their patience, their candor, and their friendship: Azzedine Alaïa, Linda Andrieux, Ria and Yiouri Augousti, Hubert Aynard, Alexandra Balme, Jean-Pierre Barbou, Yannick Bourgade, Jason Briggs, Isabelle Canno, Étienne Cochet, Clarisse Combes, Brigitte Cornand, Julie David, Jean-Louis Deniau, Matthieu Derrien, Arielle Dombasle, Simon Doonan, Mathilde Dupuy d'Angeac, Maximilien Durand, Jo Fong, Jean-Louis Froment, Cyril Fuentès, Christophe Gerschel, Frédéric Gerschel, Hassen Gouaned, Sébastien Grandin, Didier Grumbach, Stéphanie Guarneri, Youcef Hassaïne, William Holloway, Jo Horgan, Benoît Jacquot, Benedikt Kaiser, Karin Koppel, Karine de Labarthe, Séverine and Tristan de La Courtie, Monique and Jack Lang, Jimmy Lee, Amelie von Leithner, Bernard-Henri Lévy, Keiths Lieberthal, Nadia and Luciano Lucatello, Elena Luoto, Serge Lutens, Caroline Mangez, Philippe de Mareilhac, Romy Montano, Vivian Montano, Murray Moss, Aymeric Péniguet de Stoutz, Nicolas Petraut, Pierre & Gilles, Bernard Pivot, Olga Porto, Ralph Pucci, France and Cyrille Putman, Olivia Putman, Guillaume Renon, Fabien Roque, Emmanuel Santarromana, Sylvie Santini, Steffen Schraut, Anne Sébaoun, Norah Soufi, Dana and Helmut Swarovski, Nadja Swarovski, Véronique Taravel, Matthieu Tarot, Véronique Thouvenin, Sophie and Guillaume de Turckheim, Patricia Turck-Paquelier, Holly Waltrip, Juliana Young, and everyone at the Andrée Putman agency, including François Russo.

This book would not have been possible without the unconditional and daily support of Anne-Charlotte Romary.

This work is dedicated to the memory of Pierre Reynès, Secretary General of *Paris-Match*, who died at sea in Saint-Tropez, on May 21, 2004. He had introduced me to Andrée Putman three years earlier.

Andrée Putman and Pierre Reynès.

Thank you

Love Love
Love Love